"Based on the popular meditation practice of mindfulness, *Be, Awake, Create* offers exercises and advice that introduce us to the wider view of 'wakefulness,' where we learn to stop rushing past our lives and instead open to a timeless moment that unleashes our natural, creative brilliance. Rebekah's voice is wise; her advice, practical; her insights, profound."

> —**Michael Carroll**, chief operating officer of Global Coaching Alliance; author of *Awake at Work, The Mindful Leader, Fearless at Work,* and *Mindful Leadership Training*; and authorized teacher in the Kagyu-Nyingma lineage of Vajrayana Buddhism

"*Be, Awake, Create* is a useful and profound introduction to the dharma art teachings. It offers a revelation of insight, teachings, and experiential activities. The exercises are contemplative, creative, and life transforming. This is a book about making palpable the compassion and potency of creative presence to heal our hearts and transform the world."

> —**Laura Simms**, world-renowned storyteller, global educator, worldwide performer, and author of *Our Secret Territory*

"*Be, Awake, Create* is full of inspiring exercises and motivating quotations. Once you pick it up, you can't put it down; and when you do put it down, you just want to rush off and do something creative! This is a unique book, which expands the boundaries of art and reveals the vital importance of being creative. It will be an indispensable resource of ideas and exercises for anyone interested in exploring the vast potential hidden within their being."

> —**Seyed Alavi, MFA**, artist

"*Be, Awake, Create* is *The Artist's Way* for the twenty-first century, a gentle and thorough guide to next steps on the journey. For the artist who longs to land in the work more deeply, for the contemplative whose creativity yearns to bloom, Younger's book offers a beautifully designed combination of mindful and creative practices which embrace playfulness as well as discipline. Accessible enough for beginners, the book could also be used as a template for depthful learning at the meeting place of presence and artistic process, and a springboard for those powerful transformations toward which all art beckons us. I'm excited to begin!"

> —**Nancy Coleman, PhD**, clinical psychologist and writer, facilitator of Wide Open Writing, and international writing and yoga teacher

"*Be, Awake, Create* is sure to become a classic, for no other book presents meditation and mindfulness as the complete ground from which to access our creativity, while leading us through the whole experiential path. Whether for a seasoned or new artist or meditator, this interactive practice journal will bring the magic of creating out of everyday life. With simplicity, lucidity, and wisdom, Younger reveals how being present naturally leads to the reawakening of not only our awareness and creativity, but also our true humanity—a view so needed in our world today. She is to be thanked for heralding the way!"

> —**Patricia Donegan, MA**, poet, translator, professor emeritus of creative writing, Fulbright scholar, meditation teacher, author of *Haiku Mind*, and coauthor (with Yoshie Ishibashi) of *Love Haiku*

"The creative process and meditation are inherently contemplative, but they are not the same. The creative process is about discovering one's inspiration and then manifesting it. Meditation is about developing mindfulness and awareness in order to discover your own mind. Rebekah Younger's workbook, *Be, Awake, Create*, through a series of exercises and the sharing of Younger's personal journey, fuses the creative process with the benefits of meditation."

—**Steven Saitzyk**, international director of Shambhala Art, adjunct professor of humanities and sciences at the world-renowned ArtCenter College of Design, and author of *Place Your Thoughts Here* and *Art Hardware*

"*Be, Awake, Create* by Rebekah Younger is a must-read for anyone interested in developing their own creative potential of seeing and experiencing the magic of our ordinary world. Younger leads us on a symbiotic, hands-on journey of self-discovery through exercises enriching and developing our own creativity. Through activities of presenting the potential of our sensory experiences, new possibilities and insights arise. A guided source book journaling us to the essence of creative thought."

—**Michael Doucet, PhD**, Louisiana musician, composer, National Heritage Fellowship recipient, and Grammy Award winner

"This book is filled with enough wisdom and joy and encouragement to fuel an extended creative journey. Rebekah draws on her experience as a teacher, fabric artist, photographer, and Buddhist practitioner to produce language and activities that are inspirational and accessible. (I especially appreciated the links to audio instructions.) She reminds us that we constantly create through our choices and actions, and that a journey begun in stillness, conducted with attention, and enacted with compassion is of benefit to self and to others."

—**Laura Peck, MPH, MTC**, coach and consultant to leaders committed to creating a more just and compassionate world though their word, deeds, and presence

"*Be, Awake, Create* invites the reader to do just that, offering a tremendous wealth of activities that bring fresh perspectives to the creative process. Writing in a most accessible, engaging style, Rebekah Younger charts a meaningful journey, sharing her perceptive insights while gently guiding the reader to be fully present and discover the heart of their artistic vision. I highly recommend this wise, provocative, and playful book to all those interested in exploring and deepening their awareness of and creative response to the worlds in which we live."

—**Ruth Wallen, MFA**, artist, professor in the MFA interdisciplinary arts program at Goddard College, and shastri in the Shambhala Buddhist tradition

"Rebekah Younger has composed an elegant, accessible, and profound collection of practices, insights, and personal stories for those who are curious about contemplating and creating. She deftly manifests how the very act of creating can honor our interdependence with the world. I am deeply inspired by her own vulnerability, decades of experience, and innovative suggestions. Younger says, 'When you are committed to your vision and awake to reality, everything else is workable.' I will pick up this book again and again, in order to return to this truth."

—**Miriam Hall**, coauthor of *Heart of Photography*, and contemplative arts instructor

Be, Awake, Create

Mindful Practices *to* Spark Creativity

REBEKAH YOUNGER, MFA

REVEAL PRESS
AN IMPRINT OF NEW HARBINGER PUBLICATIONS

Distributed in Canada by Raincoast Books

Printed in the United States of America

Copyright © 2019 by Rebekah Younger
 Reveal Press
 An imprint of New Harbinger Publications, Inc.
 5674 Shattuck Avenue
 Oakland, CA 94609
 www.newharbinger.com

Interior art by the author

Cover design by Sara Christian

Acquired by Ryan Buresh

Edited by Melanie Bell

Library of Congress Cataloging-in-Publication Data

TK

21 20 19

10 9 8 7 6 5 4 3 2 1

First Printing

"Visual Awareness" on page 57 is adapted from *The Practice of Contemplating Photography: Seeing the World with Fresh Eyes* by Andy Karr and Michael Wood, page 140. Copyright © 2011 by Andy Karr and Michael Wood. Reprinted by arrangement with The Permissions Company, Inc., on behalf of Shambhala Publications, Inc., Boulder, CO, www.shambhala.com.

"What Color Is It Really?" on page 106 is adapted from "Learning to Paint What You See" and "Handling Color" in *How to See Color and Paint It* by Arthur Stern, copyright © 1984, 1988 by Arthur Stern. Used by permission of Ten Speed Press, an imprint of the Crown Publishing Group, a division of Penguin Random House.

John Cage quote on page 156 is used by permission of the John Cage Trust. From *John Cage Visual Art: To Sober and Quiet the Mind* by K. Brown and J. Cage, published 2002 by Crown Point Press, San Francisco.

"No Mistakes" on page 150 is adapted from Stefon Harris, "There Are No Mistakes on the Bandstand," TEDSalon NY2011. Used by permission. To watch the full talk, visit TED.com.

The following are variations on exercises in the Shambhala Art Program by Steve Saitzyk: "Seeing Clearly" (page 110); "Is This Me?" (page 114); "Touching Space" (page 135); "Making an Arrangement" (page 140); and "Yün Hunt" (page 161). Used by permission. Adapted from Place Your *Thoughts Here: Meditation for the Creative Mind* by Steven Saitzyk, published 2013 by First Thought Press. See page 240 for more information.

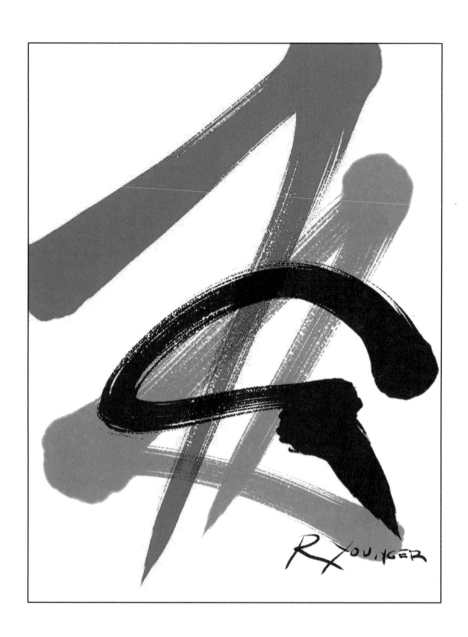

For all those inspired to be, awake, and create.

May our actions benefit others.

Contents

Introduction

We live in a universe that is constantly in a flux of creation and destruction. We are part of this ever-changing reality, creators by nature. Whether we call ourselves artists or not, we affect the world around us with every choice we make, consciously or unconsciously. This book offers contemplations, mindfulness practices, and art activities to spark your creativity by cultivating greater awareness of the world around you. We'll look at art as a contemplative path of discovery and expression of your experience.

We may create for a variety of reasons: self-expression, aesthetic, spiritual, political, or social communication; therapeutic or process-oriented healing; or simply because it brings us joy. I have personally created art for all of these reasons at one time or another. Throughout my life, art was always closely connected to my personal and spiritual growth and served as a way for me to express it.

Still, it was revelatory for me to discover that my creative process was not just a way for me to express my personal vision but could become a way for the world to communicate *to* me and others, beyond my personal story. It was amazing to find that there is such a thing as genuine expression that arises in the moment; that is not about my story, though it comes through me.

When we engage in the creative process with a wakeful mind and synchronized body, a genuine expression can arise based on our direct experience. The art communicates beyond our conceptual limitations, making the ineffable visible. This is the path of the contemplative artist, to open to the world as it is and become a vehicle

for its expression. Creating becomes a a way to wake up the maker and the viewer to a fresh experience.

This book offers you a chance to explore that territory for yourself, as many have done before. I draw heavily on my training in the dharma art teachings of Chögyam Trungpa Rinpoche, as presented in the Shambhala Art™ program developed by Steven Saitzyk. I am an authorized instructor in this program. I'll touch also on the work of Robert Fritz and his Technologies for Creating program, which was instrumental for my personal path as an artist and entrepreneur. I include links to both programs in the "Additional Resources" section at the back of the book, should you be interested in further study.

Each chapter includes inspirational quotes, guided contemplations, and activities to spark your creativity. You'll learn practices, including meditation, to relax into the present moment, where creating begins. You'll use creative processes to synchronize mind and body, to access your sensory experience, which provides a wealth of inspiration and information. Your everyday life is filled with creative inspiration when you appreciate it as it is. I'll challenge your habits of perception that limit your ability to see things as they are.

Once you are in the present and seeing with greater clarity, you'll explore the basics of any creative endeavor: space, form, and energy. You'll learn how to work with obstacles and opportunities in the creative process. You'll discover the benefits of a sustained creative practice and how to establish one that suits you. We'll look at contemplating your creations and the works of other artists to discover their personal messages for you. I'll challenge you to create in collaboration and take your creative expressions into the world to be of benefit to others. Finally, you'll be invited to reflect on the journey and its impact on you.

Each activity invites you to create, contemplate and document the process throughout the book, visually and with words. But this

book is not just for writers or visual artists. There are prompts throughout to encourage creating in your medium of choice, including music and movement. Some art media you may have used before, while some may be new to you. I encourage you to try them all and see what sparks your imagination. Ultimately, this is a place to discover who you are as a contemplative creator. Read "How to Use this Book" to get the most out of the experience and make it your own. Join me on a journey of creative discovery and expression that is, at once, uniquely personal and universal in scope.

How to Use This Book

As with any creative endeavor, you can approach this book in a variety of ways. I encourage you to take your time reading it. Let it sink in as much through the activities as the words. Each chapter is written to invite self-reflection and creative expression through experiential learning. All the concepts offered will be more meaningful when grounded in your direct personal experience. So, doing the suggested activities sequentially is highly recommended, especially if you are new to mindfulness meditation or contemplative creating.

To cultivate mindfulness, I provide meditation instruction in the first chapter. I recommend meditating at least ten minutes daily (twenty to thirty minutes is ideal) as part of working with this book. Meditation will help you connect with your state of being and cultivate the awareness needed to make the most of the activities and reflections.

If you already have a regular art and meditation practice, you may choose to start with a chapter that addresses a current challenge or interest in your creative process. Or you may decide to read through the book first and then do the activities later.

Either way, consider doing not only the activities that inspire you, but also the ones that feel challenging, or are in unfamiliar media. Each is there to increase your understanding.

Most activities use materials that are readily available, and that you may already have around the house. Use the book as a sketchbook and journal. The pages are designed for dry media, such as crayons, pencil, and fine-tipped pens. Solvent markers will bleed through. You might want to test your media on the page before using it. A separate sketchbook or journal will be necessary for some exercises or if you are reading the e-book. A cell phone or a simple point-and-shoot camera is fine for the photography exercises.

 This microphone symbol indicates when listening to a recording of the instructions is preferable. The recorded exercises for this book are available for download at the following link: http://www.newharbinger.com/32389. This will allow you to listen rather than read the instructions for a more seamless experience of the activity or contemplation.

There is no pressure to create a masterpiece or even "art," though you may be surprised by your results. The emphasis is more on being and doing than on the finished product, providing you with an experience of the concepts discussed, regardless of the outcome. Feel free to keep, share, or destroy any of your work, but please wait until you finish the book, as later chapters ask you to review and use work from earlier activities.

Some activities are designated as practices to incorporate as a regular part of your creative life. Other activities you may want to revisit to inspire new work. Some activities can be done in five minutes, while others are repeated daily for a week or more. Most, however, do not require you to spend more than a half hour at a time engaged in the activity.

Make this book your own as a record of your creative process, and feel free to share your work and insights with others using the Instagram hashtag #beawakecreate. May it serve as an inspiration for further practice on your contemplative creative journey.

Be, Awake, Create, Relate Defined

Be: To exist

Sometimes we are so invested in doing—checking off to-do lists, setting goals, making plans—that we disconnect from simply being. This book encourages you to check in with yourself before heading into a creative project, to notice and accept who you are now without striving to be better or different, and to relate to your state of being, whatever that may be.

Awake: To be conscious, alert, and aware

When we pay attention to our experience of the present moment, we are automatically more conscious and alert. That awareness extends naturally to include not just ourselves, but also our surroundings. Our experiences offer a wealth of inspiration for the creative process. Through the activities in this book, you'll become more aware of your felt experience in being here now.

Create: To bring into existence

Whether we consider ourselves artists or not, we have the capacity to create through our choices and actions. We are translating our experience into an expression whenever we tell a story, take a picture, or make a gesture. By first connecting to our being and awakening to our experiences, the expression is genuine to the moment. Throughout

the book, you'll find opportunities to take action to express your experience of being here now.

Relate: To connect to/with

Having expressed your experience, you can now contemplate what it means and share it with others. You can also engage others in a contemplative creative process with joint and group collaboration. The final chapters offer ways to reflect on your creations and share them with others.

All the mindfulness practices offered in this book are designed to spark your creativity and a contemplative state of mind. May they enrich your life and how you express it!

Part 1

be

be

Chapter 1

Relaxing into Open Space

There is no such thing as an empty space or an empty time. There is always something to see, something to hear. In fact, try as we may to make a silence, we cannot. —John Cage, composer

John Cage created a controversial work that premiered in 1952, entitled *4'33"*, which is the length of the composition. On a bare stage in the concert hall, a grand piano sat center stage. The pianist walked onstage to applause, taking his seat at the open piano. He opened the sheet music, as if to begin playing, closed the piano, and set a stopwatch. He then sat still for three timed intervals. Between each movement he reset the stopwatch and the score, which was written as bars of rests. At the end of *4'33"*, the pianist stood, bowed to the audience, and exited the stage.

Needless to say, when first performed at the rustic Maverick Concert Hall in rural Woodstock, New York, the audience was in an uproar. Where was the music they paid to hear? All that could be heard were the ambient sounds of the audience rustling on creaky benches, the birds, and wind in the woods outside. This *was* the

music John Cage wanted his audience to experience, the unintentional sounds of the present moment.

Even when viewing a later recorded Carnegie Hall performance of this piece, I found myself in a heightened state of awareness. Every shuffle, cough, or inadvertent sound in the concert hall was amplified by the performer's contrasting stillness. These sounds, the continuous music of the world, of course, would change with each performance.

In 1988, in a conversation with William Duckworth, Cage spoke about 4'33", saying, "No day goes by without my making use of that piece in my life and in my work. I listen to it every day.... I don't sit down to do it. I turn my attention toward it. I realize that it's going on continuously. More than anything, it is the source of my enjoyment of life.... Music is continuous. It is only we who turn away."

His composition illustrates the reality that the world is in a constant state of creating and expression. As part of this world, we are creators too. Creative inspiration is ever present if we remain open and inquisitive about our experience. In this chapter, I offer contemplations and activities to relax and open awareness to the fertile ground of now. You can begin by listening, as John Cage challenged his audience to do, without expectation of hearing anything in particular. Simply be in the present.

PRACTICE Listening

A guided recording of this exercise is available at http://www.
newharbinger.com/32389, along with a host of materials available
for download at the website for this book. (See the very back of this
book for more details.)

- Set a timer for five minutes to sit silently with eyes closed
 and listen attentively.

- Notice the sounds and contemplate these questions as you
 listen.

- What do you hear?

- Where are the sounds happening?

- Where do you actually experience them?

- Is it in your body? If so, where?

- Or is it somewhere outside of your body?

- Notice the sounds near you and in the distance.

- How far away can you hear?

- Are there sounds you never noticed before as you go about
 your daily life?

Write about your experience here:

Mining the Gap

It isn't necessary that you leave home. Sit at your desk and listen. Don't even listen, just wait. Don't wait, be still and alone. The whole world will offer itself to you to be unmasked, it can do no other, it will writhe before you in ecstasy. —Franz Kafka, writer

Do you ever feel uninspired or distracted by too many ideas, unsure what to express creatively? Or perhaps you are afraid to express any creative ideas at all? Maybe your life is bogged down with obligations, family, work, and other things. Even if you have a few moments to yourself, you are thinking about those issues so nothing creative or new seems possible. All of us engage in an internal running commentary, colored by our assumptions, biases, and critiques about ourselves and everything we experience, based on our past.

So, in order to create something new, there first must be a gap in the commentary. You may start with a physical place for your creation: a blank page, stage, or canvas. Yet inspiration arises with an opening in our thinking, naturally occurring gaps in our assumed "reality," like the one John Cage created for his audience in the premiere of *4'33"*. It comes in the open space where anything is possible!

Those gaps happen all the time. For a brief instant, you are disoriented, shaken out of your stream of thought. While talking on the phone with a friend, a strange sound distracts you. Walking down a busy street, a splash of color catches your eye. One of my students was stopped by the brilliance of orange tulips on her way to work. The flash of color cut through her mental chatter about the workday ahead. Taking a moment to acknowledge the gap in her thinking brightened her mood. It's easy to miss these gaps on the way to your next appointment. What if you chose to stop momentarily to fully experience that moment? What would it inspire you to do?

Instead, we let the moment pass, preferring the comfort of familiar territory. After all, we are on a mission. Who knows where this new experience might lead? Whatever it will be, we don't know yet and not knowing is uncomfortable. Not knowing can be awkward and lead to failure. So, we fill the gap quickly with assumptions or old patterns of responding, or miss it altogether.

Still, this is where creating begins—with a leap into the unknown. You can relax knowing answers will come as you engage in the creative process. Follow Kafka's advice, being still and open to the world. Perhaps the most radical and necessary thing we can do in our achievement-oriented culture is to "not do," to just be. In "not doing," you are present for whatever is happening now. With practice, you learn to trust that creative inspiration naturally arises from experience.

Being still, you see your mind and the world are endlessly creating, like weeds breaking through cracks in the sidewalk. Right now, there are sounds, sensations, colors, textures, and smells, not to mention emotions, thoughts, and memories, vying for your attention. Each, as Kafka suggests, writhes before you in ecstasy, waiting to be expressed. Take note of your gap experiences for the next week and record them on the next page.

mine the gap

record your experiences here

PRACTICE Noticing

Ultimately, the gap is not empty space—because there is no empty space. Be still and notice what is here now.

A guided recording of this exercise is available at http://www.newharbinger.com/32389.

- Set a timer for five minutes.

- Sit quietly, noticing your environment, inside and outside of you.

- Start by looking at what is in front of you.

- Notice textures, shapes, colors, and patterns of light and shadow. Note each detail as you become aware of it.

- Open to your other senses. Perhaps you feel the clothes on your body or the temperature of the room, hear a bird or traffic outside.

- As you sit, notice how your attention shifts from one experience to the next.

- Thoughts, memories, and emotions may be triggered by your experience. Just notice them.

- There is no need to follow them or cut them off. Notice how all of these experiences arise and pass away on their own.

- Finally, rest in inquisitive awareness of all that is within your immediate experience.

What you noticed during the preceding activity is your unique experience. Even if there are others sharing the same space, no two people will experience it in the same way.

Write about what you noticed, along with any observations about your experience here.

Calm Abiding Meditation

Perhaps even five minutes of "not doing" was challenging. Or if you are an experienced meditator, you may have been surprised how quickly the time went by. Meditation benefits any creative practice by increasing your ability to be present, open, and aware of your experience. Whether you are experienced or new to meditation, meditating for at least ten minutes daily, using the following instructions, will enhance your understanding of the material in this book.

Being present to notice your actual experience and environment takes practice. Meditation helps synchronize your mind and body. You are training your mind to be present with your current experience, including your internal commentary, whatever it may be. Becoming familiar with your thought patterns increases not only self-awareness but also awareness of the world around you, beyond your habitual patterns of thinking.

In meditation, you are taking time to be with yourself as you are. There is no place to go and nothing to be done. This might sound simple, but it's not necessarily easy. Being present with ourselves in whatever state we are in is a great gift. We might offer our full attention to a child or friend, but perhaps balk at doing it for ourselves. Meditation is about being with and making friends with yourself unconditionally.

Perhaps you already have a meditation practice. Indeed, there are many skillful ways to meditate. The practice I suggest using for this book is referred to as *shamatha* or "calm abiding." The attention is placed on the breath to strengthen our inherent mental faculties, to be present and aware.

I give written instructions for this technique, though I highly recommend receiving in-person instruction from a trained teacher, if that is possible in your area. So much is communicated nonverbally by the instructor. I have included a list of training resources in the

back of the book, including online videos to initially guide you through the practice. I encourage you to download the recording for the following exercise so you can follow along without needing to read it.

PRACTICE Meditation

A guided recording of this exercise is available at http://www.newharbinger.com/32389.

Posture

- Start by taking your seat in either a straight-backed chair or on a meditation cushion (*zafu, gomden*, or kneeling bench—see the image on the next page), depending on your personal physical needs. The posture should be uplifted. Experiment to find the seat that works for you. It is fine to adjust your posture during meditation as needed if you are feeling extreme discomfort.

- Sit upright on a chair, both feet flat on the floor, without leaning against the back of the chair. Or sit cross-legged on a cushion tall enough for your knees to rest below the level of your hips. If your hips are too tight to sit cross-legged comfortably, try a kneeling bench.

- Your spine arises gently in a natural curve from your pelvis, so your breath can move freely in your chest. If you are not used to sitting with your back unsupported, this may feel uncomfortable at first. But as your core muscles strengthen, it will become easier to stay in this posture longer.

zafu

zabuton

gomden

kneeling bench

- Shoulders and arms are relaxed, but not hunched. If you are feeling tight, lift your shoulders to your ears and then let them drop. This will help to release the tension.

- With your arms at your sides, lift your forearms to rest your hands gently on your thighs with palms face down.

- Tuck your chin in slightly to open up the back of the neck.

- Relax your jaw with your mouth slightly open and your tongue resting on the upper palate behind your front teeth.

- Keep your eyes open with a relaxed, steady gaze resting on the floor about six feet in front of you. Your eyes are open receptors softly taking in whatever is in view without focusing on anything in particular.

- Sit in this posture for a minute or two, just being aware of your physical presence.

Breath

- Let your attention settle on the physical sensations of the breath as it moves in and out of your body.

- Feel your chest and belly rise and fall with each breath.

- Perhaps you notice the cool air moving into your nostrils as you inhale and the release of warm air as you exhale.

- Just follow the breath as it happens—no need to control its movement.

- Rest your attention on the movement of the breath.

Mind

- Whenever your mind becomes distracted by thoughts or feelings, bring your attention gently back to the physical experience of the breath. This cultivates your mind's ability to stay in the present, as the breath is in constant motion. Simply allow yourself to be with the experience of sitting and breathing. Follow the breath and be.

- When thoughts arise, gently return again and again to the feeling of the breath in the body. With each return, there is greater awareness of not only what drew you away, but also your ability to come back to the present.

Practicing Meditation

Initially it can be disconcerting to realize how many thoughts arise in each second and frustrating to see how difficult it is to stay with our breath for even a moment. Still, we have the inherent ability to notice when we are not with the breath and return to it. By the time we realize we have gone, we are back. Like doing reps in a gym, with each return, we are training the mind to be with the breath.

That initial flood of thoughts may feel overwhelming. It's not that you are having more thoughts; it's that you've never been still long enough to notice the constant chatter. This isn't about stopping the thinking. It is about becoming familiar with your mind and detaching from its flow. We use the breath as a reference point to return to when our thoughts carry us far away, such as to our to-do list, next vacation, or difficulties with our boss.

Just like going to the gym, meditation needs to be done regularly to reap the benefits. Plan to spend at least ten minutes daily in the beginning. Frequency and quality of attention are more important than the length of the sessions. If you miss a session, just start fresh with the new day. As with any new practice, it develops over time.

Even after years of meditating I can, at times, have lapses in my practice. I find I am more reactive and less creative when that happens. It helps to have a community of fellow meditators, attend group meditation sessions, or read books to stay motivated. You don't have to do it by yourself.

Set a scheduled time for practice and stick with it. Sit in a location where you will not be disturbed and set a timer to eliminate the need to check the clock. Consider sitting as a prelude to your studio time. With practice, you can sit for longer sessions.

Over time, you'll see patterns to the distractions and "weather" of your emotional and mental states. Returning over and over to the present, you may notice some space around your thoughts. This gap in your internal commentary is useful in the creative process. You can see how your assumptions filter your experience of the world, and that there are other valid experiences beyond your reference point. You learn to be with your experience without needing to change it. You accommodate more of life, expanding your sources of creative inspiration. Relaxing into the gap with greater ease, you become a witness of your creative process as much as its creator.

PRACTICE Creating from Open Space

Use this warm-up practice to connect you with your creating materials and state of mind. Creating without a set goal opens your awareness, breaking the ice for further creativity. The creative process will be a form of meditation in action in whatever art media you choose: writing, music, dance, or something visual. Instead of following the breath, as in sitting meditation, you'll place your attention on the physical act of creating. As a warm-up, the aim is spontaneous action rather than creating a masterpiece. Let the critic go. Just create until you are done.

- Set out your materials for this practice session. They might be pencil and paper, a musical instrument, clay, fabric, a craft project, a computer, your body, or something else.

- Sit quietly for five to ten minutes just noticing your environment, your physical sensations, your emotional state, and state of mind. There's no need to rush into activity, even if an inspiration arises. Just sit and be for a few minutes.

- When you feel settled, shift your awareness to your materials, appreciating their physical presence, such as color, texture, weight, and size.

- When you feel ready, take your first action: make a mark, sound, word, or movement. No prior planning necessary. Let it arise spontaneously. Whatever you do will be fine.

- Pay attention to the action from start to finish.

- Appreciate the result and your response to it, whatever that might be.

- Allow it to lead to another action and another.

- As much as possible, stay with the feeling of the experience rather than planning or criticizing. If those thoughts arise, let them go, and come back to the feeling of the materials and sensations in your body as you create.

- Continue working until you sense you are done.

- Take time to appreciate the finished piece.

Consider doing this exercise daily as a warm-up for your creative process. You can document the results in a separate journal as a record of your contemplative art journey while working with this book. Don't engage in interpreting or critiquing what you create yet. Chapter 9 suggests how to contemplatively view your work and the work of others.

CONTEMPLATION Your Experience of Open Space

What helps you relax into open spaces and the unknown?

What are you discovering through these practices?

List what inspires you to create.

Describe your experience of spontaneous creating.

Track your engagement with each of these practices over the next week.

my practice

	listen	notice	meditate	create
m				
t				
w				
t				
f				
s				
s				

Whatever feelings come up with these practices, just notice them. Keep coming back to your felt experience. Be open to the unknown. Creativity will flow. The world is brimming with fuel for our creative process. Each chapter will take you deeper into the journey. If you are struggling to slow down, the next chapter provides more options for settling the mind, so you can be awake and aware of this bounty.

Chapter 2
Being on the Dot

Being without doubt means that you have connected with yourself, that you have experienced mind and body being synchronized together. —Chögyam Trungpa Rinpoche, *Shambhala: The Sacred Path of the Warrior*

Long before I learned to meditate, I was an avid knitter—so much so that my mentor, Rhythmistic artist Professor Turtel Onli, MAAT, suggested using my knitting for artistic expression. He observed that a large unfinished painting remained on my easel for years, yet I spent hours knitting compulsively. I would create more artwork by knitting my art. While I eventually finished the painting, I took his suggestion. I started designing knit garments to exhibit in wearable art shows. For the next twenty-five-plus years I worked as a fiber artist, creating and selling thousands of garments showcased in museum exhibits and craft shows and on magazine covers.

What did I find so compelling about knitting? I was relaxed in the present, without concern for the past or the future; I was on the dot. The feel of the fiber, the repetitive motion of the needles, and the richness of the colors connected me to my physical sensations. I

was totally absorbed in the activity, without doubt or hesitation, because my mind and body were in sync.

The soothing repetitive motion lulled me into a contemplative state or kept me closely focused, depending on the pattern I was knitting. I might drift into a reverie, moving to the steady rhythm of a ribbing or garter stitch. Working on a complex pattern required me to pay closer attention; counting stitches or following a chart meant being aware and in the present moment for extended periods of time. Slowly turning a length of yarn into a garment, my hours of effort were measured in inches of knitting. Only later did I realize this was a form of mindfulness meditation in action. When I began machine knitting to produce my garments for sale, there was still handwork to do mindfully.

Perhaps you practice a craft or other repetitive activity that helps you be present. In this chapter, we'll look at ways to use a creative practice to synchronize mind and body. In combination with meditation, creating can reduce stress and increase your awareness. Mindful repetitive creating, in particular, is useful when you feel speedy and unable to focus. It can help you settle before a creative or meditation session.

Dance or other physical activities also help to synchronize your mind and body. The following activity is a moving meditation to synchronize your mind and body before a creative session.

PRACTICE Twenty-Minute Dance

We access our innate wisdom when we attend to our physical experience, bringing heart, mind, and body into alignment. This practice engages awareness of your body, noticing when you are present with its sensations and when you are lost in thought.

Read all the instructions before you begin or download the audio instructions. A guided recording of this exercise is available at http://www.newharbinger.com/32389.

- Basically, your body has two states, stillness (shape) and action (motion). This practice has no goal other than feeling your bodily sensations as you alternate between these states. While it is called a dance, the activity is simply being in the body. No preparation, judgment, or thinking required.

- Set an incremental timer for twenty minutes, broken into two intervals of ten-minutes each.

- Start by lying on your back in a space large enough for you to move freely. Feel your body supported by the ground, the earth's body.

- Close your eyes and feel the breath in your abdomen.

- Extend your awareness to other parts of the body and its presence in space as a whole.

- Over the next twenty minutes, you will alternate between stillness and action in whatever manner you choose, beginning low to the ground. Let action spontaneously arise from your body's present experience. The shape is where you land between actions. The motions can be as small as moving one finger or can incorporate the whole body. Don't bother planning out your next move. Just return again and again to your physical sensations, letting the body guide your action and stillness.

- Over the course of twenty minutes, you will move gradually from lying down to sitting to standing. The timer will sound halfway through your session.

- In the final minutes, move around the room with a lowered gaze to keep your focus inward as you move your body further into space.

- When the final bell rings, settle into one last shape.

- Throughout, place your attention on the body and its sensations, allowing them to direct the practice.

- Reflect on your state of being after the practice. Write about your experience here.

- Then move out into your life with greater awareness of your body and the space it occupies.

This practice can be a daily warm-up to creating or a way to reconnect with your body when you feel disconnected.

ACTIVITY Mindful Mark Making

A line is a dot that went for a walk. —Paul Klee, painter

This activity uses mark making to cultivate mindfulness by noticing when you are present with the activity and when you are not. This is simply making a series of marks. It's nothing special, so there is no way to do it poorly.

Instead of using your breath as the object of meditation, place your attention on the act of drawing lines. Whatever is created is not the point. Use it as a mindful warm-up before your creating session, like practicing brushstrokes, scales, or dance exercises.

- Set a timer for ten minutes.

- Begin on the next page.

- With pen or pencil, draw a line, being mindful of making the mark from start to finish.

- Draw another line parallel to the first, placing your awareness on the act of drawing.

- Continue to draw parallel lines of any length with the same level of attention, until you notice yourself thinking about something other than the act of drawing. When that occurs, draw a new line in a different direction, returning your attention to drawing parallel lines now in this new direction.

- Each time your thoughts stray, shift direction, drawing parallel lines in the new direction on the same page.

- Continue until the timer rings.

ACTIVITY Drawing with Each Breath

- Define your own guidelines this time for marking the page with each breath.

- How will your marking shift when you realize you have stopped following the breath?

- You will create a repetitive pattern that alters with a change in your awareness, marking each breath.

- Set the timer for ten minutes and begin on the facing page.

Mindful or Mindless Activity

There is no guarantee that repetitive activity cultivates mindfulness. It depends on where you place your attention. You can either be mindful or mindless. Being mindful means you are present with an activity with an attentive and inquisitive mind. The activity becomes the object of your meditation. Just as with sitting practice, when the mind strays, you gently bring it back to your present activity. You attend to the physical sensations of what you are doing, synchronizing mind and body.

In a mindless state, your attention wanders from what you are doing. You daydream, watch TV, talk to others, or simply space out. While your body is active, the mind is elsewhere. You are not fully present. Mindful engagement in an activity strengthens your ability to be present, not only with the current activity, but also in other parts of your life.

When we are in sync, we can direct our minds to contemplate a specific intention with each repetition. Intentional creating imbues the creation with the energy of that intention. For example, those who knit prayer shawls offer prayers for the recipient with each stitch. Tibetan monks create mandalas with tiny grains of colored sand, while visualizing the enlightened aspects of the deities. Creating becomes a sacred ritual.

The repetitive activity calls forth our embodied wisdom by aligning the head, heart, and hand in the present. You can then direct your attention, for example, to staying present with the activity, contemplating a goal, sending loving kindness to someone, or generating a positive quality, like compassion, equanimity, or devotion. The activity keeps you grounded in awareness, returning to your intention with each repetition.

ACTIVITY Working with Intention

Bring mindful attention to your creative work and other parts of daily life. Try knitting, another fiber art, woodworking, or any other craft. Art forms like dance, singing, or playing an instrument are also possibilities. Even household activities can be done mindfully, such as cooking, washing dishes, gardening, or physical exercise, like running or yoga.

- Choose to do one mindful activity for at least twenty minutes daily for a week.

- Before you begin, determine what your intention for the practice will be for that day.

- Notice when you are mindful or mindless in your practice.

- Chart your week of mindful activities on the next page.

- Use colored pens or pencils to indicate your mood at the beginning and end of each activity.

mindful activity

	activity	intention	outcome
m			
t			
w			
t			
f			
s			
s			

How did your experience differ day to day?

How did your state of mind affect the outcome?

How did the activity and setting intentions affect you?

Cultivating Beginner's Mind

Whenever we learn a new skill, we start with not knowing. We don't even know *what* we don't know, because it is all new territory. It can be an exciting place of discovery. Yet it can also be humbling to be awkward and make mistakes. You may choose to give up out of frustration, thinking you aren't talented enough to do it. Don't expect to be an expert from the start. Learning any new skill takes practice. Here is where patience, gentleness, and awareness are so vital.

ACTIVITY Listening to Yourself

This activity records your internal commentary as you create. Thoughts are simply thoughts. You can think anything and then let the thoughts go, without judging them or yourself for having them. Noticing doubts, hesitation, or critical comments without letting them derail your creative practice is similar to working with thoughts in meditation. You simply notice them. Then you return again and again to creating as you would the breath. When you can detach from thoughts consistently, the commentary has less impact on your ability to create. We don't need to make those inner voices into gods or demons—they are just thoughts. Later, you may want to examine them further or you can let them go.

- Choose a creative activity that you find challenging or try one you enjoyed in the past, using an unfamiliar medium.

- Be aware of both the activity and your thoughts as you create.

- What are you telling yourself in the process?

- Say the thoughts out loud, into a recording device, even as you continue working. Try not to edit yourself, just say what you are thinking as you continue creating.

- Keep working this way until you feel your creation is complete.

- Take a few deep breaths, relax, and then do the activity again.

- This time, when the inner commentary starts, continue creating without verbalizing or following the thought. Instead, reconnect with your body in the act of making.

- If emotions arise, feel the physical sensations in your body, then return your attention to your materials and the creative process.

- When you are done, look at both creations and listen to the recorded thoughts. Examine what happened as a curious observer.

What did you learn?

Is there a difference between the two creations? If so, what?

What emotions and sensations arose with each activity?

Write down any other insights.

Going with the Flow

When you are fully engaged in your creative process, a natural flow occurs. You feel what to do next, often at a nonverbal level. Self-conscious doubt and discursive thoughts don't distract you, so you can act without hesitation. Being fully engaged in the present, you have the information you need to create. Doubt pulls you out of the moment, opening the door for voices of past critics, a fear of failure, or a sense of inadequacy to show up and sabotage the process. When this happens, the mind has split from the body and you are no longer present. Coming back to your physical experience realigns the mind and body, reconnecting you to the flow.

Still, there is a place for thinking as you create. Your thoughts help you to determine the parameters of your creation before and review the results of your actions after. The act itself happens without much thought. Insight arises naturally because you are present and can discern what is needed based on observation. With practice, you learn to trust your choices over time.

Along the way, you discover there are no bad choices, only more information to incorporate into future decisions. For example, you design a tailored outfit using flowy silks. The garment doesn't hang on the body as you would like. Next time, you choose a firmer fabric to get the structure you are looking for. Each choice you make either takes you closer to or further away from your desired result. When you assess the result accurately, you know what your next move needs to be. How do you know what is working and what isn't? You perceive it. With a synchronized mind and body, you can access the information you need without being confused by internal chatter.

ACTIVITY Create and Color Flow

Materials needed: Fine-point felt pen and crayons or colored pencils

You will create a spontaneous design to color, as you wish, to practice making nonverbal choices based on your felt experience. Touch the pen to paper and see where the hand goes next. Each mark is in ink so you are fully committed to it. After each mark, notice how it changes the composition.

- On the next page, make a drawing or doodle in ink.

- Let the creation be spontaneous as you watch the lines form.

- Then color it as you wish.

- Notice when you are in the flow of the experience, when doubt or judgment arises, or if you space out, losing connection with your body altogether.

- If that happens, come back to your physical sensations.

- Even with a glimmer of an idea, go for it and see what happens next.

- Try this activity daily, for a week or more, to see how the drawings evolve over time.

- This activity could also be done as a daily spontaneous poem, song, or dance, instead of a drawing. Just document your creations in some way, so you can revisit them in the future.

ACTIVITY Your Mind/Body Connection

When you relax into open space, settle the mind, and synchronize it with the body, you are developing mindfulness as part of your creative process.

What have you discovered about your mind-body connection?

What activities help you settle the mind and be aware of your body?

How did synchronizing the mind and body affect what you created?

What is the feeling when your mind and body are out of synch?

How did setting an intention for your practice influence what you created?

How does spontaneous creating differ, if it does, from how you have created in the past?

Part 2

awake

awake

Chapter 3

Opening the Sense Gates

All our knowledge has its origin in our perceptions.
—Leonardo da Vinci

You wake up to the sound of your alarm and feel the warmth of your bed, maybe the furry presence of your pet sleeping beside you. Opening your eyes in the dim room, you pull back the covers, sit up, and touch the carpet with your feet. Pulling open the blinds, you feel the warm sun on your face and notice the activity on the street below. You smell the coffee brewing and taste the mint toothpaste as you brush your teeth. Each of these sensations is a gateway to the world accessed through your awareness.

As we learned in the last chapter, synchronizing mind and body opens us to insight and a flow of creativity. It is through our five senses that we connect to our bodies and the world around us. They are our interface with the phenomenal world. First, we feel the sensation. Then our mind registers and interprets or ignores that experience. How and what we choose to notice of these experiences defines our "reality." So, awareness of our senses directly impacts what we create.

So far, I've emphasized settling the mind by placing your attention on the act of breathing or creating. This trains us to be mindful and present. Once we are present, our awareness naturally opens out to include more sensory input, our emotions, and our mental state.

Our sensory experience begins before we label it with thoughts, preferences, or emotional reactions. It is the direct experience of our physical sensations that is preverbal. We access this information through our awareness. Let's look at how awareness of our sense perceptions feeds the creative process.

ACTIVITY Limitless Perceptions

When you are open and curious, you'll find that your perceptions are limitless. There are a multitude of sense perceptions in any given moment: sounds, sights, smells, and so on. We are the ones who stop looking because we think we already know something. As the adage goes, "I know it like the back of my hand." Let's take another look at that part of our body we think we know so well.

- Look at your nondominant hand. What do you see?

- Look with an open, curious mind, as if you had never seen it before.

- Notice all the colors, shapes, lines, textures, and shadows.

- Look for at least five minutes. The more you look, the more you see.

- Add touch, smell, and taste to your investigation.

- From your exploration, make a creation—visual, written, musical, or in movement—based on your observations.

What did you discover?

Each observation provides more detailed information about your hand. Eventually, you may reach a point where words drop away altogether and you just see its unique is-ness. As the title of artist Robert Irwin's biography suggests, "*Seeing Is Forgetting the Name of the Thing One Sees.*" With that level of attention, an intimacy develops between you and the object. You might even fall in love.

Making Sense of the World Through Our Senses

While perceptions are limitless, the capabilities of our sense organs are not. For example, we can't hear the pitch range that a dog can hear or smell as acutely as one. As we age, we may lose our hearing or sense of smell. So, what we perceive is always a limited slice of reality. We adapt, often filling in the gaps with our assumptions, like an amputee might experience a phantom limb. We try to "make sense" of the world through our perceptions, which are colored by our thoughts, creating our version of reality—a relative truth.

The brain acts as a gatekeeper to our sensory experience. It filters the input from our sense organs further, depending on where we place our conscious attention. How often have you driven a familiar route and not been aware of any of it, lost in thought about something else? When we are distracted by our thoughts, we miss vital information from our senses, like the exit ramp you missed while thinking about what you will say when you get to your friend's house. It's important to realize we are always selectively relating to the world. What we presume is reality is only a small slice of the truth.

Our sense perceptions provide valuable feedback as we create. Visual artists improve their ability to draw by learning to see the subtleties of line, shape, color, and texture. Likewise, a musician cultivates a discerning ear for sounds. Increasing your sensory awareness is essential for art mastery, whatever the medium. It might even make us better drivers!

ACTIVITY Visual Awareness

Where you place your awareness determines what you perceive. We'll use visual perception, as sight is a dominant sense for most people. Our eyes record whatever is in front of them, like a camera, but it is our awareness that registers what is seen. This exercise will make this clear. You may want to download the recording so you can listen to the instructions as you do this exercise. A guided recording of this exercise is available at http://www.newharbinger.com/32389.

- Look directly in front of you, with a relaxed gaze not focusing on anything in particular. Your eyes simply perceive whatever is there.

- Without moving your eyes, shift your awareness around the field of view.

- Start by paying attention to what is above the horizon line in front of you. What do you see? How high can you identify distinct details without moving your eyes?

- Shift your attention to the right. What do you see on your right without moving your eyes?

- Shift your awareness to the lower half of what is in front of you. Notice that with this shift, what you saw above the horizon line is less distinct.

- Then shift your awareness to the left.

- Now bring your awareness back to the front.

- Close your eyes. Notice any afterimages, patterns, or colors.

- Reopen your eyes and focus on one small detail in your field of view. How does this affect what you see?

- Now notice the space around that detail. How does this alter your vision?

- Shift your awareness between foreground and background of one object in your field of view. How does this change your perception?

What did you discover about vision and awareness with this exercise?

The mind stands in the way of the eye. —Arthur Stern, painter

This is a great exercise, particularly for photographers. It's important to look around the perimeter of the camera's viewfinder before taking a picture to be sure that only what you want to photograph is in the picture. Tunnel vision is a problem for photographers. Being so intent on a small detail in the distance, like a bird in a tree, your mind ignores everything else. Afterward when you look at the picture, the bird vanishes in the foliage. It was so prominent in your awareness when you took the picture. That is why photography is a great way to hone your visual awareness. The camera does not have your brain attached to it, filtering the world. What is in front of the lens is what it captures indiscriminately. We'll explore this further in future exercises.

ACTIVITY Sensory Wander

Now we have seen how awareness is an essential part of our sensory experience. For your next activity, take a walk in your neighborhood, placing your attention on what engages your senses.

- To synchronize your mind and body before starting your walk, take several deep breaths with eyes closed. Feel your breath moving your body and notice the sounds around you.

- Open your eyes and walk outside.

- Relax into your physical sensations. Whenever your mind drifts away from that awareness, take a breath and reconnect to your senses.

- Aimlessly wander for at least twenty minutes around your neighborhood or a park, with no particular route or goal in mind. Just go where you are drawn to in the moment.

- Be curious.

- Notice sensations as they arise and observe which perception is vivid enough to draw your attention. It might be the texture and color of a wall, music from a restaurant, or the scent of a flower, for example.

- Let curiosity be your guide, investigating further things that either attract or repel you.

- Whatever it is, spend a few minutes just appreciating your experience of it.

- Then let go. Return to the sensations of your body walking until a new sense perception piques your interest.

- There's no need to hunt for the next perception. Just walk until you are drawn to something new.

- Let your impressions from the walk become the subject of a creative act when you return home.

What was your experience?

Which, if any, sense was dominant during the walk?

Were there any surprises? If so, what were they?

How did you feel after the walk?

Consider doing more wanders, attending to one sense at a time.

Notice your sense perceptions throughout the day: while eating a meal, talking with friends, taking a shower, or just sitting. Just take a couple minutes to be fully present with all the sensations in your body.

What impact does this have on your week?

Cultivating Sensory Awareness

We can bring awareness to our senses at any moment. We may hear the sound of crickets, feel the ache in our fingers, smell freshly cut grass, see the vivid red of a flower, or taste the bitterness of black coffee. Each sensation provides new information about the world: valuable feedback, direct and simple, to use in our creative process.

While feeling a sensation can be simple, discerning *what* we perceive can be muddled by our thinking. As we grow, we edit our sensory awareness, filtering input based on survival needs, past experience, personal preferences, and social conditioning. We try to avoid unpleasant experiences. Sensations, however, include pain and pleasure, beauty and ugliness. Our senses do not discriminate in their feedback. Our minds do. We would rather smell the roses than the compost pile, see a sunset than roadkill. So, our mind filters our awareness based on past experience, leading us to numb out rather than experience certain sensations.

Being sentient means that, as humans, we process our world through our sense perceptions and our emotional responses. When we disassociate from either form of feeling, we lose touch with a vital part of ourselves. So, it is important to feel your physical sensations and your emotions to make a clear and direct creative expression.

Greater awareness allows more information to pass through our filters. This leads to more skillful choice making. We can notice how our thoughts and assumptions distort reality, jumping to conclusions based on past experience. Our memory banks are like libraries we constantly reference to make sense of the world. The substitution of past experience for direct perception can muddy our creative expressions. Let's see how this works in the next activity.

ACTIVITY Touch Drawing

With this activity, you'll explore how your mind makes sense of a physical object only through touch. As accurately as possible, you'll translate your touch sensations into a visual form. Notice when you are referring to your actual experience and when you are making assumptions based on past experience or associations with other objects. Paying attention to your thought process as you draw is more important than the quality of the completed drawing.

Materials needed: Small mystery object, brown paper bag, and pencil or pen

- Enlist the help of a friend or family member to place a small object, at least the size of an apple, into a paper bag, without telling you what it is. No peeking!

- Without looking into the bag, use your nondominant hand to feel the object. Even if you can guess what it is, drop naming it and return to the actual feeling of the object.

- What are its qualities? Hard/soft? Smooth/rough? Organic/geometric? Symmetrical/asymmetrical?

- Draw the object in detail with your dominant hand as you touch the surface with your other hand.

- Add more detail with each new impression.

- Draw multiple views, as needed, to show all your discoveries.

- When you are done, take out the object and compare it to your drawings.

Notice how you used your senses and mind to figure out what was there and translate it into your drawing.

How is the drawing representative of your sensory experience?

How did the sensation differ from the drawing?

Were there any surprises? If so, what?

What did you learn in the process?

If you guessed what it was, did it help or hinder your ability to draw the object?

Did you stop touching the object and just render an approximation of it?

If you didn't guess, how did that affect the experience and your skill in rendering the object?

Sensory Awareness Prompts

Feeling awareness takes slowing down the thinking process to notice:

- relationships between things
- contrast
- shapes
- colors
- space
- rhythms
- patterns
- echoes or aftereffects
- shadows
- reflections
- sounds
- smells
- tastes
- the beginning, middle, and end as the sensation shifts over time
- the fluidity of experience

Expressing Your Sensory Experience

Have you ever noticed how certain colors are vibrant and certain sounds are joyful? Through our senses, we receive energetic messages from the world. This energy feeds us emotionally, spiritually, and aesthetically. We use our sensory experiences as creative inspiration. How you perceive will influence what you express. That expression becomes its own sensory experience. Even if we could replicate an inspirational moment, no two people will "feel" it the same way. Here are a few creative activities inspired by sensory experience.

ACTIVITY Sense Poem

This exercise can be done at any time or place, when you want to connect your inner and outer worlds through sensory awareness.

- Sit quietly until you notice a sensation.

- Write the first words that come to mind from the sensation. The more direct the statement, the better. This is not about mulling over the "right" words. Just write whatever pops into your head from the experience, whether it "makes sense" to you or not.

- Notice another sensation and write another line.

- You choose how many lines and when the poem feels complete.

- Read what you have written and contemplate how the combination of sensations and words reflects where you were in that moment.

ACTIVITY Sense Pairing

Our sensory experience is seldom limited to one sense at a time. Let's look at how our senses overlap and support each other. We'll play with pairing the senses to see what happens when translating one sense's experience into another's expression. This phenomenon is referred to as synesthesia. For our purposes, just allow your imagination to play with the idea. As with all these exercises, let your response be spontaneous and intuitive rather than analytical. There are no bad responses.

- Draw the sounds you hear.

- Make sounds for the textures you feel.

- Take a bite of something and move your body in response to the taste.

- What is the smell of a color?

- Imagine the flavor of a sound.

- Make up your own combinations. Have fun.

Refreshing Your Awareness

Imagine drawing without looking at either your subject or the drawing. What if you made music without hearing the notes being played? You'd miss valuable feedback to determine what to do next. The information you receive from the world changes constantly, so it is important to update your awareness with fresh perceptions over and over in the creative process. Continue to be curious. We can trust our sensations. Awareness of them is innate and can be refined with time and attention. We can be awake in our creative process and bring that heightened awareness to our whole life.

PRACTICE A Sensual Feast

Eating a meal is an opportunity to engage all your senses creatively, updating your awareness with new perceptions along the way. When done mindfully, it feeds you not just physically, but also aesthetically. I have provided an audio link for initial instruction, however, to fully experience this practice, do it in silence, with no books, music, TV, or conversation to distract you. Instead, place your attention on preparing and eating a meal.

- Prepare a one-bowl meal (hot or cold), such as cereal, a salad, or stew. Appreciate the sensual qualities of the utensils, bowl, and each ingredient in the process.

- Set the table simply. Place the food in a bowl.

A guided recording of the following instructions is available at http://www.newharbinger.com/32389.

- Before you start eating, just sit, enjoying the look and smell of the food.

- Take your first bite. Notice the smell as you bring it to your mouth.

- As you chew, notice the texture of the food. Is it wet or dry? What temperature? Are there different flavors in different parts of your mouth? Different textures? How do they change as you chew? Notice the beginning, middle, and end of each bite.

- Put down your fork or spoon between bites. Just be with each bite. There is no need to rush.

- Look at the colors, shapes, and textures of the meal between bites. Notice how the appearance changes. Look at each spoonful as you raise it to your mouth.

- Notice the sounds of your chewing and the environment. I remember one retreat meal where the quiet of the meditation hall was interrupted by the crunch, crunch, crunch of fifty people chewing slightly undercooked green beans. We all broke out laughing.

- If your thoughts wander, come back to the physical sensations of eating.

- Sit for a couple minutes after eating and enjoy the feeling of a full belly.

- Take the time to mindfully clean up after eating to complete the practice.

I predict you will feel full from eating less food than usual because you are feeding all of the senses. While you may not want to do this for every meal, it can actually increase a sense of shared intimacy when done with friends and family. It is a great way to reduce stress. This is not about becoming a "foodie." It can be done with the most basic of foods and still be a rich feast for the senses. The meal itself is a creation and may lead to other creative expressions based on your experience.

CONTEMPLATION Your Sensory Experience

How do your sense perceptions impact what you create?

How do your senses enrich your life?

How do your senses wake you up?

Write about a sensory experience that remains vivid from your wander.

Chapter 4
Appreciating Everyday Life

If we open our eyes, … our minds, … our hearts, we will find that this world is a magical place. It is magical not because it tricks us or changes unexpectedly into something else, but because it can be so vividly and brilliantly. —Chögyam Trungpa Rinpoche, *Shambhala: The Sacred Path of the Warrior*

For my fiftieth birthday, I attended my first month-long meditation group retreat. Each day consisted of four periods of meditation interspersed with physical activity, talks, contemplative meals, and chores. Much of the retreat was in silence and yet there was a sense of community. Life became very basic with this routine. There were many moments of boredom and physical pain, along with peace and delight. People often ask me how I could sit for twenty-eight days. I tell them I didn't do it for twenty-eight days. I did it one moment at a time, discovering along the way that whatever I was experiencing was not permanent. That realization made it possible.

By the third week, my allegiance shifted from the chatter of my mind, which alternated between critique, fantasy, and wanting another now, to the vaster space in which all of this was happening. My eyes, heart, and mind opened to the world and I saw how *being*

could be so vivid and brilliant. The safety of a supportive container at the retreat center helped me to relax. Still, it took courage to be that open and vulnerable, even with myself.

Being open to the vividness of life, on its terms, was challenged only months later when I underwent heart bypass surgery. My creative life at that time was consumed with managing my fine art knitwear business. Just as I was preparing for the major wholesale show of the year, life came to a screeching halt when the surgery literally cracked my chest open.

Depression followed in the months after the surgery. I was forced to rethink my creative process, business, and life's direction as the days of discomfort turned into weeks. Lying on the couch, feeling fragile and bored, I became acutely aware of my senses. I noticed the quality of light in the room, the brilliant colors of the get-well bouquets, and the texture of my robe. Being accustomed to "not much happening," from the retreat experience, I began looking contemplatively at the world around me. I found there a vividness of being that inspired me to live: the magic of everyday life.

I first noticed the afternoon light on an orchid. I was captivated by the iridescent glow through its petals. Looking more closely, I picked up my camera to record what I saw. Photography became a tool for my recovery, teaching me to see clearly. I realized my images would be the only record of the flower's life in full bloom, now long gone. Their life fed mine and helped me to heal.

As I continued looking at the flowers, I photographed the beauty of their dying process too. I discovered that the vivid energy I received from the flower had more to do with my quality of attention than its inherent vitality. Magic is present all around us, as much in dying petals and ordinary moments as in fresh flowers and transcendent experiences.

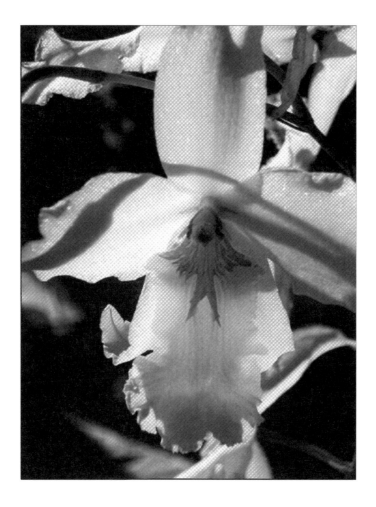

I had the good fortune to participate in the month-long retreat, yet my awareness was honed initially by practicing meditation daily at home. You may already be noticing greater awareness in your daily life thanks to meditation. Regular practice will strengthen your ability to stay awake and present. Opening your senses can be delightful and inspiring, yet it can also be painful and even overwhelming at times. It takes courage to stay awake. Keeping the mind and body connected is challenging, especially when we want our experience to be other than it is.

CONTEMPLATION Staying Open to Your Experience

What scares you the most about being open to all your experiences?

How has meditation helped you be present for more of your life?

How does experiencing pain and pleasure impact your creative process?

Describe a vivid and brilliant experience you had that led to a creative expression.

If it has, how has your art been part of your healing process?

Our day-to-day life is shaped by habitual patterns that can dull our awareness. Yet flashes of perception, like the light through the orchid's petals, can break through our shell, inviting us to experience the vividness of the phenomenal world. By relating to ourselves and things as they are, we develop the courage to be awake and open to simply being. When we do, the most commonplace of experiences are magical. As Henry Miller wrote, "The moment one gives close attention to anything, even a blade of grass, it becomes a mysterious, awesome, indescribably magnificent world in itself."

Most of life is spent with the minutiae of the mundane. We go through the motions, but how much of it are we aware of? How often are we lost in reminiscing about highlights from our past or planning for a better future? Rather than striving for a particular outcome or distracting ourselves with various forms of entertainment, we can open to our experience as it is right now. As Chögyam Trungpa Rinpoche once said, "Since we are here, why not *be* here?" When we bring inquisitive awareness to daily life, we find inspiration for our art.

ACTIVITY Ordinary Magic Photography

Use a smartphone or camera to record moments when the ordinary magic of the world touches your heart and wakes you up. We reach for our phones anyway to share our story, to declare, "I am here." I encourage you, with this exercise, to record moments of vividness that you might normally overlook. What in the phenomenal world is quietly calling out to say, "look at me?" Take time to see it. Take a picture of that. This is not about taking an "arty" shot. Rather, it is about taking the time to actually look and see your everyday world as it is. Let the image come to you.

- Place your camera beside your bed the night before doing this activity.

- On day one of this five-day challenge, when you wake up, take a photograph of what you first notice is vivid while still in bed.

- Then, take another image while sitting on the edge of the bed.

- Take one more in the bathroom.

- Another as you dress.

- And a final one at breakfast.

- On day two, repeat this activity, taking five pictures at the end of the day.

- On day three, take five pictures throughout your workday, including lunch.

- On day four, take five pictures randomly when you notice yourself reaching for the phone as a distraction or babysitter.

- On day five, compile your images into a montage either on your computer or a large sheet of paper.

- Reflect and write down any insights using the prompts below.

What did you discover?

What did you see for the first time that was probably there all along?

How did each day/time differ?

How were they the same?

What experiences were most vivid?

How did this activity affect your experience of the day?

Were there any moments when you were bored?

How did boredom affect what you photographed?

Were you inspired to notice and photograph other moments in your day?

How did the activity change your relationship to your phone and the world, if at all?

How do these images as a whole express your everyday life?

ACTIVITY Everyday Expression

Many great works of art were inspired by quiet, mundane moments: Monet's *Haystacks*, Van Gogh's *Bedroom in Arles*, Edward Weston's black-and-white photographic portrait of a toilet entitled *Excusado*, for example. We don't need exotic places, extreme situations, or grand concepts to make meaningful art expressions. There is art in everyday living.

- Choose one routine activity, ordinary object, or space from your everyday life as inspiration for an artistic creation. You might write a poem about your morning cup of coffee or a song about your closet, paint a picture of your toothbrush, or create a dance incorporating the movements you make in the shower, for example. Consider using the images from the Ordinary Magic Photography activity as inspiration.

- Write about your creative process for this activity here, reflecting on how this communicates something about you to others.

- Consider your everyday activities and environment as extensions of your creative process, giving them the same mindful attention. How would doing so change your habitual patterns of living?

Taking Time to See

When we take the time to look at our everyday life, we may find greater appreciation for it. Georgia O'Keeffe, when writing about her flower paintings, noted that "to see takes time, like to have a friend takes time." With prolonged attention, we develop an intimate connection with what we observe. Whether we draw a detailed sketch, feel energy shifts in our body as we maintain a yogic pose, or listen intently to a complex piece of music, each takes us deeper into the present moment. We can bring that level of attention to any everyday activity. When we do, we find it is an enriching experience. Time seems to stand still because we are fully engaged.

That's the way I feel when I am arranging or photographing flowers. Hours pass before I notice I have not eaten. In the flow of the moment, it's as if I have vanished. The self-conscious commentary stops; there's just the material and the action. There is no duality, so the relativity of time no longer applies. Where now and here meet, "I" is nowhere.

CONTEMPLATION Time Standing Still

Reflect on an activity where you lost track of time.

What were you doing?

What was the quality of your attention?

How did it feel?

What was the result?

ACTIVITY Snail's Pace Vision

Materials needed: Sketchbook or three sheets of paper and drawing media of your choice

Doing this activity, even if drawing is not your medium of choice, is a wonderful opportunity to slow down and really see. If your thoughts stray to critiquing and doubting your process, just return to the physical act of looking and drawing. This is not about creating a "great" work of art. Simply look closely and record, as best you can, what you actually see. Read through all the instructions before you start.

- Choose an area of your personal space that can be left untouched for three days.

- Sit quietly and just look at the space. No need to set up a special arrangement.

- Before you begin, decide how much of the scene you will draw. Make it workable for you.

- Draw in detail everything you see in that area, including shadows and textures, using whatever media you choose.

- Take your time. Imagine you are a snail, moving slowly over every inch, as you draw it.

- Don't fret over exact accuracy; just do your best to record what you see.

- Draw what you actually *see,* not what you *think* should be there. This requires looking carefully.

- Start by noticing the shape of the objects and their shadows.

- Draw the contours of each shape as if you were an ant traveling around the perimeter.

- Notice that, from your current vantage point, some things are overlapping. How does this affect the shapes and shadows cast?

- Fill in the gradations of light and dark.

- Be as detailed as possible, as if you were a camera taking in everything you see.

- Feel free to spend more time on interesting details, highlighting them as you choose.

- Notice how there is always more to see. You choose when the drawing is done.

- On the second day, start with a new page.

- Draw the scene from the same angle of view, beginning with a different object, shadow, or shape from where you started the first drawing.

- Again, draw everything you see, taking time to look deeply.

- If you notice anything that is different, highlight it with a change in style, color, or size.

- On the third day, change your position to draw the same scene from a new direction. What do you notice this time?

- Are you as engaged in the snail's vision as you were with the first drawing, or do you find yourself quickly sketching in areas you have drawn before? Can you step back and look at it freshly, as if drawing it for the first time?

- Now look at all three images side by side.

How did your impressions shift over time?

What did you notice about each drawing experience?

How did working at a snail's pace affect your state of mind while drawing?

Alternative approaches to the exercise could be:

- Write about the same scene in as much detail as possible, from a different perspective each day.

- Compose different musical arrangements of the same daily soundscape.

- Use movements from one everyday activity to choreograph a different dance each day.

This activity is about closely observing your day-to-day world, delving deeper into your actual experience of it as you create an expression of that experience. In the end, you may find that thinking drops away and you are just expressing it.

You can apply this level of mindful attention to making a cup of tea, cleaning the house, or listening to a friend. In this way, life becomes artful, as you attend to the details of everyday living. It's a matter of cultivating awareness, intention, and attention.

Surrendering to Now as It Is

What happened in the third week of the retreat to shift my thinking? It wasn't that I ran out of things to think about. I frankly became bored with my own thoughts, with all the ways I tried to escape being there mentally: rehashing memories, fantasizing about futures, complaining about aches and pains. There was no escape. I finally surrendered to the experience of now, whatever it would be.

No longer in a struggle with my mind, it was a great relief to open and appreciate what actually was there. It was a surprisingly rich world to experience: the sunlight streaming through the windows, the sound of the evening lark singing outside, settled still-ness within. My awareness expanded to include all this along with the mental chatter about the ache in my back, the obsessive thoughts of a past lover, and following the breath, at the same time. Each moment was a fresh experience that arose without any effort on my part. I became curious about what would happen next. All I had to do was be open and appreciate it. The world came flooding in, expressing itself on its own terms.

Chögyam Trungpa Rinpoche referred to this place as "cool" boredom. You settle into the space of not much happening and it is enough. I realized that wanting another now was a waste of energy,

for now is always exactly what it is, regardless of our desires. When we relate fully to now as it is, we can experience the magic of its vividness and brilliant ordinariness. The struggle falls away.

So, when boredom arises, relax into the experience. No judgments, no fear, just be there. You really can't die of boredom. Surrender to it and see what happens next. Something fresh will engage you. The shift may surprise you.

There is tremendous freedom when you take your foot off the mental gas pedal and coast for a while. Observe and appreciate, still being alert and present. Cool boredom can act as a way to disengage from the struggle and make a shift. This opens new avenues for creativity.

ACTIVITY Window Gazing

This activity will challenge you to stay in the moment when not much is going on. Recorded instructions are available for download at http://www.newharbinger.com/32389.

- Sit in a chair so you can comfortably look out a window in your home.

- Start a timer for fifteen minutes.

- Take a few deep breaths and relax into your chair as you start. Look ahead with a soft gaze at eye level or slightly above.

- Notice the sensations in your body and your state of mind.

- Shift your awareness to your peripheral vision, being aware of the immediate area around your chair.

- Now notice the surface of the window glass, any reflections, and how they affect what you see beyond the glass.

- As your mind settles, notice what is outside the window.

- Note the larger shapes.

- Observe any details within those shapes.

- Remain curious, noticing what draws your attention.

- Note any movement. Even in the stillness, the light changes and shadows shift.

- Notice any changes over time.

- If you drift into thoughts about the exercise, or become bored or sleepy, take a deep breath in and exhale forcefully to reconnect with your body.

- Keep gazing out the window, noticing what you notice.

- At the end of fifteen minutes, express your experience in a medium of your choice, with these questions in mind.

What did you notice?

What surprised you?

What emotions did you experience?

What thoughts arose?

Everyday Experience as Inspiration

Our everyday world is sending us messages all the time—signs we receive with greater clarity if we are attentive to our senses, remaining open and inquisitive about what we perceive. You see the spaciousness of the sky, feel the firmness of the earth beneath your feet, rain is wet, and the midday sun is bright. Sirens shriek and dust settles. With a contemplative mind, everyday experience offers an endless supply of creative inspiration. The world shares its wisdom with us as we perceive it. As artists, we are channels for its expression. Our ability to do this is a precious gift, one we offer to others so they might find greater appreciation of the world and its wisdom, too.

CONTEMPLATION Your Everyday World

How does paying attention to the details of your life make it a work of art?

How do you relate to your boredom?

How have you experienced the world's wisdom expressing through you?

Chapter 5
Perceiving Things as They Are

We do not see things as they are; we see them as we are.
—Anonymous

The world communicates to us and through us all the time. It breaks through our internal chatter suddenly in flashes or comes quietly in moments of stillness to wake us up and we respond. Chögyam Trungpa Rinpoche referred to that genuine response as "first thought, best thought." First thought is best because it is most true to the experience. It does not necessarily mean it will be the first thought we think, as that might be our habitual response. Yet it will be the freshest and most vivid expression, unencumbered by doubt, bias or self-judgment, all of which can appear in almost the same instant as our direct experience. How will we know what is genuine?

Through meditation, we are beginning to see our habitual patterns of thinking and how they color our perceptions. The information we receive through our senses gets filtered by our concepts of what we expect to see. To communicate with greater clarity, we need to understand the relationship between our sense perceptions and how our thoughts affect what we perceive. Greater awareness and

trust in our felt experience develops as we practice meditation and contemplative creating.

How do you distinguish between your projected ideas about things and direct perception of the thing itself? This is important territory to explore as a creator. What you discover will impact how and what you create.

Chögyam Trungpa Rinpoche spoke of "such a thing as unconditional expression that does not come from self or other. It manifests out of nowhere like mushrooms in a meadow, like hailstones, like thundershowers." That freshness of expression arises from direct experience.

ACTIVITY Concept or Direct Experience?

This activity explores the distinction between creating from our concepts or a direct perception. Conception extrapolates from past experiences. It is your idea about something rather than the thing itself. Perception is tied to your sensory experience in the present.

Materials needed: Drawing materials and an apple (or other piece of fruit)

- Imagine eating an apple.

- Write down what you imagined.

- Then draw an apple without looking at one.

We are working with the concept of "apple." Are any of these an actual apple?

- Now, actually pick up a piece of fruit (ideally an apple) and take a bite.

- Perceive the color, texture, and feel of the fruit. You know exactly how it tastes, bite by bite, and what it feels like chewing it. You may notice spots or changes in coloration, and the shape and size of it as you eat it. Notice, too, how the light falls on it and what it feels like as you swallow. This is direct experience, ultimately beyond words. This piece of fruit is communicating its exact nature to you.

- Create an artwork that communicates some aspect of your direct experience on the next page or document what you created there.

Notice that there is greater specificity to inform your expression after having had the direct experience.

Is your expression an apple?

How is your creation its own direct experience?

How did creating based on direct experience shift your expression of "apple"?

What direct experience does your creation provide the viewer?

Because it all comes down to how you answer a single question: Is the moment of perception—that first moment, before all the abstracting, conceptualizing processes that follow—is that the moment closest to or furthest from the real? Everything depends on how you answer that question. —Robert Irwin, visual artist

Perception begins with what our senses perceive and our awareness of them. Concepts are an abstraction based on past perceptions colored by social conditioning and learned patterns of thinking. Concepts are generalized, absent the specificity of actual experience. They point to something but are not the thing itself. Both perception and conception are part of the creative process. The story of this image illustrates how perception and concepts relate.

I remember the exact moment when this photograph was taken. It was at the end of a daylong meditation retreat at the local meditation center. As I stood to leave, I saw the stark divide of light and dark bisecting the clear oil lamp on the glass shrine table. Its crisp precision stopped me in my tracks. Looking further, I noticed that the light on the lamp cast shadows and reflections onto the table and wall behind it. This was a moment of direct perception. I pulled out my phone to photograph it, making this first image.

The contrast between the sharp clarity of the lamp and the ephemeral nature of the shadows was visually compelling. I continued to take additional pictures from other angles, not trusting my first thought. Yet in the end, this remained the strongest image, truest to my actual experience. First shot, best shot.

When viewing the image later, I realized that it was a perfect expression of my state of mind in that moment. The clarity of the oil lamp expressed the clarity I felt after a day of meditation. The shadows and reflections expressed the echoes of a thought or sensation as I sat. These are concepts based on contemplating the image from my point of view. The oil lamp image reminds me of an experience that was beyond words. I did not plan ahead to make an image to express my experience. I felt compelled by the perception, in that moment, to take the picture.

CONTEMPLATION Oil Lamp Reflections

Take another look at the picture of the oil lamp. Contemplate it as a metaphor for the process of perception. The oil lamp represents a direct perception of the actual object, very specific and detailed. The light illuminating it is your awareness, which registers the perception. The shadows cast on the wall and table are the impressions left in your mind, thoughts clouded by past experience and assumptions. And the highlight of the surface reflection on the wall is your conceptual understanding of it. Each impression of the lamp is further removed from the direct experience, including this photograph.

How do they differ?

How would an expression based on the specific oil lamp differ from one that starts with the reflection on the wall?

Contemplate this image and the Robert Irwin quotation. What is your experience?

Write down any insights you receive.

Think about an artist's work that you found inscrutable before reading an explanation from the artist.

What was your experience of the work before the explanation?

How did the artist's statement change your experience of the work?

When artwork is based on a conceptual framework not shared by the audience, it can feel inscrutable. That is why it is helpful to understand the distinction between concepts and direct experience as you create. Let's look at how our concepts can distort our perception and impact what we create.

ACTIVITY What Color Is It Really?

We talk about colors as if they are absolutes like red, green, or blue, yet even if we are not color-blind, we all see color differently. Even when we do agree on a color, it will appear differently to our minds depending on the context we see it in. Try this activity to see this for yourself.

Materials needed: One plain white index card and scissors

- Cut out a 1/4-inch square in the middle of the card.

- Hold it up at arm's length to view different areas of a white wall or other large white object through the hole.

- How does the color vary from one area to another?

- Is any part as white as the index card?

- Explore other parts of your room using the card to isolate colors.

- How does your perception of color change?

- Were you surprised to find things you think of as red, blue, or yellow are really purple, gray, or dark green?

- Our mind conceptually labels colors based on what we expect to see. Painters, therefore, have learned to isolate color with this tool to render it realistically in a painting.

- Try this exercise in different light conditions. How does the lighting affect your perception of color?

Filtering Perception

We also substitute generalized assumptions for our actual perceptions based on previous experience. We know what a chair looks like, so we don't really look at this particular chair, on this particular day, in this particular setting and lighting, to recognize it as a chair and sit down. But what if we had never seen a chair—what would the quality of our attention be? How would we know its purpose? To see requires stepping back from concepts and assumptions to really experience what is before us. When we do, it's as if we had never seen it before. The experience becomes totally fresh and unique.

As children, initially, the whole world was unfiltered and fresh. Yet, from the moment we understood the word "juice" would get us a cool drink of something sweet, we have substituted concepts for experience. Over time, our opinions about things become increasingly based on past experience and concepts rather than actual observation. This becomes a bubble of self-confirming data that

skews our view of ourselves and the world around us. We only see what we're expecting to see. This can make clear communication difficult in our art and life.

Still, these mental shortcuts are useful, which is why we use them. Our attention is only placed on the information in our environment that we believe directly impacts us. For example, I am currently sitting in a teahouse, writing. Other people are in conversation in the space, but I'm oblivious to what is being said as I concentrate on writing this sentence. I also filter out the activity on the street, though I face the window. Yet once I step outside, I'll be looking both ways to cross the street.

It's a matter of where we place our attention. We would be in constant overload without this filtering system. Yet, as a writer, I might find inspiration in the conversations taking place around me. What else am I missing that would contribute to my work? The dialogue at the next table might be the beginning of a whole new book.

It's important to realize we never have the full picture. We are always filtering our experience. People and things exist independent of us. Stepping out of our myopic habitual patterns, we discover they have their own messages independent of us. It is possible for us to see beyond our projections. Taking time to perceive first provides more information for our creative process.

ACTIVITY Seeing Clearly

This is an exercise in seeing things as they are.

- Choose a personal object, approximately the size of base-ball, so all of it can be seen with a steady gaze.

- Write what it is.

- Sit in a meditation posture with the object in front of you on a plain background at a comfortable viewing distance.

- Sit comfortably, gazing at the object.

- Sit for a total of twenty minutes, using it as your object of meditation.

- When thoughts arise, notice them, but don't follow them. Just rest your attention again on the object.

- You may find yourself wanting to analyze or create stories about the object to entertain yourself. Let these and other thoughts go and return to just looking.

- When the time is up, take three photographic "portraits" of the object that express the essence of what you saw, includ-ing any details you found interesting.

- Write what it is based on your observation.

- How does your first description differ from the photos and what you wrote after sitting with it?

Stop! Complete this exercise before you turn the page, so your experience will not be colored by the next paragraph.

There is the subjective or relative truth of things based on our story (and multiple perspectives) and the direct expression of the thing itself. For example, perhaps you first wrote that your object was a locket your mother gave you for your wedding. Notice that this description is more about your relationship to the object than the object itself. After observing it in meditation, the personal reference point falls away and you start to see the object as itself. You see a silver heart-shaped piece of metal on a chain, or a series of lines, curves, and patterns with texture and shadows, or further still, something with no words to describe it at all.

We can see the qualities and traits of the object or person independent of us. When we use this information in our expression, the viewer doesn't need our personal story to relate to the work. The viewer can experience the expression directly. What is communicated may still be filtered through their own habitual ways of seeing. Still, if our communication is clear and direct, we can sometimes awaken them from their story too, to see with fresh eyes.

The Story of "Me"

Meditation helps us become familiar with our internalized story. As we disengage from the running commentary by returning to the breath, we find spacious moments of just being, moments not defined by a fixed identity. We begin to see how our concept of "me" colors what we perceive and express. Artists are encouraged to express ourselves through our work, to tell our individual story. But who is this "me" that is expressing?

Through meditation, we discover that "our" story is constantly shifting. We are constructing it with each interaction, emotion, and choice we make. Out of habit, we relate to everything in the world as an extension of us, from our reference point. When we realize we are in constant flux, we can let go of seeing ourselves as a fixed identity. In seeing the world on its own terms, the question arises, "Perhaps it has something to say through us that is not about us?"

Of course, what you create will still be unique, because there is only one you. You do not need to cook it up. It happens naturally, because you are the only one with this combination of experiences, perception, and skills. In truth, your version of "me" is one of your creations.

ACTIVITY Is This Me?

In an age of personal branding and endless selfies, "who am I?" psychology and self-help books offer questionnaires designed to categorize and define you. We work with coaches to connect with our "inner child," "higher self," or "better self." Let's observe our actual experience of "self" beyond these concepts. When Buddha observed his experience of self, centuries ago, he questioned if there was a self at all. I encourage you to examine this for yourself with this activity.

- Write a description of yourself for someone you never met, such as for a dating app. (Include physical attributes, personality traits, career, interests, and so on.)

- Ask a family member, colleague, or close friend to write one about you too.

 Look at both descriptions and consider the following questions:

 - How are they the same? How do they differ?

- Are there traits you neglected to mention that were in the other person's description?

- Were there any you disagree with?

- Were you surprised by anything they wrote?

- Notice what other qualities you want to add after further thought.
- Take one trait from your description. How has it impacted your life and worldview? Write about it.

- How has it changed over the years?

- Does it shift in different contexts or with different people?

- Is this you?

- Make a collage of images based on this description of "you," using images from your phone, the Internet, and magazines.

- Is this you?

- Take another look at the montage of images from the Ordinary Magic Photography exercise.

- Is this you?

- Contemplate both compositions.

- What did you learn about your "me" story from these constructions?

- Notice how each piece of the exercise is constructing "me," but none expresses the totality of "you." The description is constantly in flux and what others see of "us" is through their filters too.

- Now take time to just gaze at yourself in the mirror. Who are you? Express that nonverbally with movement, sound, or imagery.

- Is this you?

- Which is your "true" self?

- Is there such a thing? If so, can its totality ever be communicated?

- If you believe in a "higher" self, how is that different from who you are now?

- Is who you are now the same as who you were ten years ago?

- Can you expect to be the same ten years from now?

You may realize at this point that the story of "me" is your own creation. Who you really are is not static and always an open question. Knowing this, there's no need to take "you" so seriously. We can take the ego out of the equation and create beyond our personal reference point. We may see how our filters have limited our view of the world and that there are other valid perspectives worthy of expression. We might begin to see the world on its own terms without rejecting it if it challenges our personal viewpoint. Rather than muddying the waters, these multiple perspectives actually clarify our communication with others, because we are working with reality as it is rather than our interpretation of it. Our channel is clear for a genuine expression to come through.

Part 3

create

create

Chapter 6
Creating

Love is what creating is all about.... In the creative process, love is generative rather than simply responsive...a creator is able to love something that does not yet exist—even in the imagination—and bring it into existence. From nothing, something is formed. —Robert Fritz, creator

It began at dusk on a California beach in Point Reyes National Park. The entire sky was a smooth transition of luminous color, from dusty salmon to deep lavender, reflected in the receding tidewaters below. I experienced such tranquility and joy viewing the rich hues magically melting into each other! I photographed the fading afterglow, longing to stay there forever. Experiencing that moment inspired an entirely new direction for my art.

As knitting was my primary art form, I wanted to create a knit garment to express the beauty of that sunset. How could I recreate this subtle gradation in my clothing? I was frustrated with early attempts using commercially dyed colors that I changed every few rows. This created stripes no matter how many shades of color I used. I wanted the colors to blend seamlessly like the evening sky.

After knitting several striped sweaters, I decided to try again, designing a knit kimono for an art-to-wear exhibit. I hired a fellow fiber artist to dye fine silk yarn in seventeen sunset hues. I chose to break up the stripes with a vertical pattern using two closely related shades in each row to reduce the impact of the stripes. I would change one color at a time, every few rows, which did make the stripes less noticeable but still visible.

The design included inset rectangles of reversed color gradations to suggest the reflected afterglow in the wet sand. Juxtaposing the contrasting gradients created an excitingly unpredictable placement of color combinations in the finished garment. Having complementary colors, such as lavender and golden yellow, side by side caused the colors to really pop.

I loved the contrasting gradients, yet the kimono took more than 100 hours to complete because of all the color changes. This was

definitely a one-of-a-kind garment! There had to be a faster way to create a smooth gradation of color. Then came the "aha!" moment.

Machine knitting plain panels of fabric can be done in minutes, unlike hand knitting. I would do what was unthinkable for hand knitters. I would knit two separate panels, hand dye each with an even gradation of color, then *unravel* them and reknit them together into a two-color pattern in one garment. There would be two lengths of yarn, each with a smooth gradation of color. For example, I might dye one panel blue to violet and the other red to yellow. The two lengths of unraveled yarn would then be knit in a pattern starting with blue next to the red gradually transitioning to violet and yellow. My process had moved beyond recreating the sunset to working with the unpredictability of combining two color gradients in one knit pattern.

I started innovating techniques to accomplish my vision, learning how to dye knit silk and creating formulas to calculate the knit yardage needed for dyeing. Then I designed sweaters featuring the dyed patterns that could be produced affordably. The sunset inspiration morphed into an endless array of creative possibilities.

Gradient-dyed knits became my signature look as a fiber artist, and I sold hundreds of sweaters featuring dye techniques I developed. I wrote an article for *Threads* magazine describing my knit-dye-unravel-knit process. Now knitters can buy pre-knit panels to dye in their own color gradations. All this came from that one evening on the beach. Creating is like that. You never know where a creative spark will lead. It starts from a single moment of being open and awake, followed by hours of activity to express your inspiration.

Though creating and reacting use the same letters, creating starts with "c," as in seeing first. We take a fresh look, unconstrained by past experience. Insight and inspiration arise by being open to this moment. We bring something new into existence in response. This is creating. The expression will be unique, because now and here are never the same.

Reacting is using past experience to dictate how to respond in the present. The "c" is buried in the middle of the process; we respond with habitual patterns and then see the result. If I continued to think as a hand knitter about creating gradients, I would never have discovered my technique. Being here now means we are open to something fresh arising, even a fresh way to relate to our reactivity.

I prefer the word "creating" rather than "creativity," because it is a verb, indicating activity, rather than something someone has as a talent or learned trait. Creating is as simple as placing a flower in a vase or as complex as making a movie. If we remain open to our experience, we all have the ability to create. We create our lives with the actions we take. We create community with the people we choose as friends and how we relate to family. We might create our

home, events, or even a business. Not all creating is art and not all creators are artists.

Each choice and action we take impacts what we create. Whether the act is spontaneous, intuitive, or deliberate, creating brings inspiration into form. If you think something, it's simply an idea. Once it is expressed, it becomes something more tangible, something to relate to. For it to become a creation, action is required. You are giving birth to an outcome, whether it is art or a life.

CONTEMPLATION Your Creative Process

Consider how the last paragraph relates to your own creating. Write about the process of one of your creations. How did it create an outcome inspired by an experience? It could be an artwork, event, or accomplishment in your life, large or small.

In this chapter, we'll look at the various components of any creative act and how being awake in this dynamic process leads to fresh and vital expressions.

Joining Now and Here

So the bandstand...is really a sacred space...you have no opportunity to think about the future, or the past. You really are alive right here in this moment.... Everyone's listening. We're responding. You have no time for projected ideas. —Stefon Harris, jazz vibraphonist

Meditation and the awareness exercises help us be present in now and aware of here. When we join them together in the creative process, being here now, a fresh and genuine creation is born. You communicate your experience by making choices and taking action, a natural consequence of the energy generated by joining now and here.

Now is pregnant potentiality, an ever-fluid space where inspiration arises. There is room for something to happen. The possibilities are endless. Only in the present can we act. You can't create in the past, though memories may inspire your creations. You can make plans for the future, yet in the present, they are but a dream. These are thoughts that may lead to creating. Yet the actual act of creating happens in real time—now.

Here is very specific sensory input from the environment—your direct experience. This is current reality, what you create with, including materials, tools, and resources. Through sensory awareness, you perceive what you have. Then, you choose what to do with it. Clarity of perception leads to clarity of expression. Now is

grounded in the reality of here. This is where creating takes place.

Your conscious awareness is the energy that brings these two together. It was my awareness of the Point Reyes afterglow that inspired a creative response. Someone else could have expressed that experience as a painting, poem, wash of colored lights on a gallery wall, or not at all. Throughout the process, the creation might have shifted to something else or been abandoned altogether. Yet, I wanted it to be a knit garment and used the materials and resources available to make that happen. Each experiment gave me new information and a new now and here. I cared enough not to abandon my vision or deny the reality of my materials. This provided a dynamic energy to fuel my creative process. With each step closer to the vision, the energy became stronger and each setback was an opportunity to commit to what mattered most about the vision. These three principles are at the core of every creative process.

Ancient Taoist philosophers referred to these principles as a natural hierarchy of heaven, earth, and man (human). Heaven is the open space of potentiality and the aspirational aspect of vision. It is the all-accommodating nature of being present in the now. Earth is form, the workable and yet concrete nature of here. We, as humans, relating

properly to heaven and earth, join them together through our actions. We are the creative energy, the spark that arises from their union as an expression. It is not that we have dominion over heaven and earth, as Western philosophers would have us believe. We act as a channel; it is through our awareness that they meet. In this way we are creators. When we act in accordance with this hierarchy, creativity flows.

ACTIVITY Creating

Stop. Be now.

Notice here.

What comes next?

Express it.

That is creating.

Create something on the spot now here or write about what you did, if it was off the page.

How is your creation an expression of the energy generated by joining now and here?

So far, I've talked about these principles in general terms as illustrated by my experience. Let's connect them to your personal experience with the following contemplations and activities to explore space/now/heaven, form/here/earth, and energy/expression/human in the creative process.

ACTIVITY Experiencing Space

Materials needed: Smartphone or camera, art materials, and sketchbook or your media of choice.

Physicists point out that the universe is primarily space, whether at the atomic level or in a galaxy. It's so all-pervasive that we pay more attention to things *in* space than space itself. In this activity, we'll pay attention to space for a change. The questions offered are for you to contemplate as you walk outside. You can listen to the audio instructions as you walk and comment on your experience when you return.

A guided recording of this exercise is available at http://www. newharbinger.com/32389.

- Begin indoors.

- Close your eyes and tune in to spaces within your body, the expansion of your rib cage, the chambers of your heart pumping, the cavity of your mouth and stomach.

- Experience the space around your body, between you and the walls of the room.

- Now, open your eyes and slowly turn to gaze around the room, placing your attention on the spaces around and between things. How does that differ from your normal way of looking?

- Now, with your awareness attuned to space, head outside for a walk, bringing your camera with you.

- What spaces do you notice as you walk?

- Use all your senses to experience space.

- Notice the distances between sounds and smells, spaces between and around objects.

- Notice how your entire body is affected by the space it is in.

- How does distance shift your experience of the space between things?

- Do you sense any energetic shift based on how close you are to people or things?

- Do some objects or people command more space around them than others?

- As you walk, let your awareness be open and accommodating.

- Take time with each experience.

- Photograph the visual space between things. Use video to record spaces that include movement.

- Complete your walk.

- Reflect on the images of space after the walk.

- Write down some observations about the spaces you experienced here.

- Create something that expresses your experience of space.

The Japanese have a specific term for an interval of physical or temporal space, *ma*. It is the opening of an entryway, the well of a cup, or the pregnant pause between words or notes. These intervals emphasize what comes before and after; they encourage reflection. We notice the moon when framed in the space between tree limbs, or the sound of a lark piercing the stillness of the forest. In art, space provides contrast to form. In Western art, we call this "negative space." But the Japanese do not consider this a negative or an absence of form. Space has its own presence. *Ma* also refers to functional space that would leave an object unusable if it were absent. For example, with no well in the cup, it could not hold your coffee. If there were no pauses in music, there would be no rhythm, and it is the space between words that makes them readable. Spaces invite a response.

What examples of *ma* did you experience in your walk?

ACTIVITY Touching Space

This exercise explores what happens when you place things in space. You will place objects sequentially, not altering their position until all items are placed. Look at the completed arrangement and then remove all the objects and start fresh.

Materials needed: Half-sheet of letter-size paper, two coins, and length of string or thread (at least twelve inches long)

- Place your attention on the blank paper.

- Feel where to place the first coin on the paper. Place it where it feels just right.

- Notice how that affects your experience of the space.

- Now place the second coin in relation to the first.

- What happens in the space between the coins? Between the coins and the edges of the paper?

- Now add the string to the arrangement on the peper.

- How does the string affect the arrangement?

- Repeat the exercise four or five more times, starting over with the first coin each time.

- Notice what happens with each new composition.

- Write down any insights here.

- Try it again, placing the string first and then a larger and a smaller coin.
- Make several compositions using this order.

How did starting with the string change the resulting compositions?

What else did you notice about these compositions and your experience of space?

Were there any compositions you wanted to alter after your initial placement? Why?

Did you want more options or objects to fill the space?

How did you know when it felt just right?

We start with open space. Then, by adding a contrasting form, that space is defined. The relationship between space and form is what determines our final creation. Without intervals of space, distinct forms would not exist. Likewise, we are more aware of space contained within or touched by form. So, at the most basic level, arranging forms in space is what creating is all about, whether we work with physical space or temporal space.

I liked to wander the coastline of Maine creating arrangements with my ex-husband using large rocks as the stage and adding found objects washed up on the shore nearby. We called it "art chess." We took turns placing one object after another, responding to the previous person's choice. As a spontaneous collaborative activity, we never knew what we would find or how we would respond to the other's contribution. As a result, the outcomes were always fresh. Their temporary nature contributed to a playful expression.

I learned about object arranging and the principles of heaven, earth, and human through the Shambhala Art Program. Chögyam Trungpa Rinpoche introduced this practice to his students to train them to relate properly to things based on the object's inherent qualities. The first object, in this case the upright rock at the top of the image, and its location set the tone and scale of the space by providing the heaven element. The second object, the curved rusted metal scrap, was placed in response and grounded the arrangement as the earth element. The third, a curved bleached stick and smaller stick fragment, expressed the spark of energy or human element that arose as a natural consequence of joining heaven and earth.

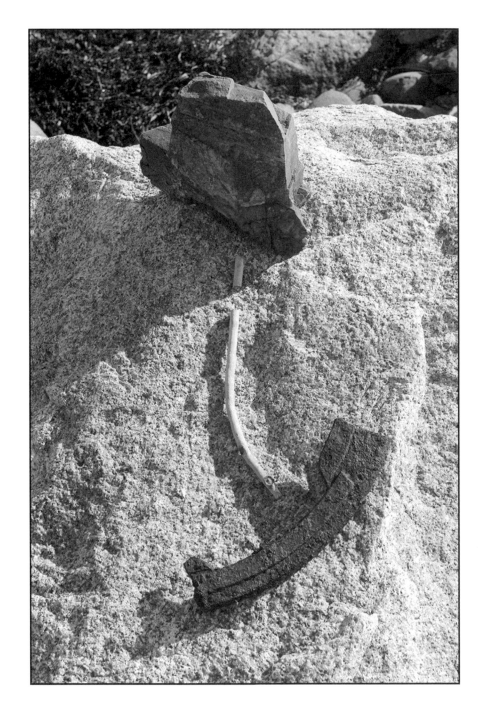

ACTIVITY Making an Arrangement

This activity allows you to experiment with object arrangements based on the principles of heaven, earth, and human.

Materials needed: Three separate objects of different shapes, ranging in size from a baseball to a basketball

- Make an arrangement with any three objects in a space of your own choosing: a tabletop, corner of the room, or other open space. Once again, place one object at a time and do not alter its position once it is placed until the arrangement is complete.

- Choose which object to use based on your felt experience and the inherent qualities of the object. Then place it based on feeling, as you did with the Touching Space activity.

- Take time to notice how the space shifts between placing each object.

- The first object invites space, determining the scale of the arrangement as it will be the predominant object in the arrangement.

- The second object is placed in relationship to the first object, grounding it.

- The third object is a natural consequence of the energy between the first two objects and the overall space.

- You are building a relationship between the three objects based on mutual respect, enhancement, and a sense of humor.

- Don't overthink your selection. Allow it to be an intuitive process.

- Notice how each arrangement feels after completing it.

- Repeat this activity with just three objects two or three times, changing which object is placed first and where it is placed in the space.

Are certain objects better suited to be heaven, earth, or human, based on their inherent qualities? If so, why?

What are you noticing about heaven, earth, and human with this exercise?

What happens if you add more objects?

Do they help create a pleasing outcome or muddy the composition?

It is possible to create with more than three objects, however, there is greater clarity of expression when the additional objects are used to support the three main elements rather than compete with them.

Working with Form

One of the keys to embracing creativity is recognizing that even though it involves risk, you don't die. —David Usher, musician and artist

In now, a thought arises, an inspiration of what to make. You may consider various options to refine the idea or just dive in, letting the process dictate the outcome. Either way, your experience of here comes into play. The spaciousness of thought is grounded by form. This is the place where you take action to shape the creation. If it stays in the realm of thought, unexpressed, it is never manifested. To make it real it must be formed. Current reality is concrete yet malleable, influenced by our perceptions and choices.

Since form is concrete, taking action has consequences. That first stroke of paint or stepping out on stage is a leap of faith. It can feel intimidating. You may hesitate on the brink, second-guessing your choices. Creating requires courage and daring. That first step can seem huge, but learning to act on your first thought is a start. You can trust your felt experience. Any step is better than no step at all. By starting in a direction, you get feedback that makes the next step clearer.

It's all about making choices and taking action. You can trust your ability to perceive and learn. The fear may always be there, but trust in your ability to discern what is needed grows with practice. Stepping out into open space becomes exciting, not just terrifying.

By choosing when and how to shape space with your materials, you create. It might be choosing which words to write, colors to paint, or notes to play. You can practice making choices. Notice how your mind makes connections between even random choices with the next activities.

Remember "first thought, best thought" because it comes before doubt or self-criticism step in. If you find yourself hesitating, re-center in your body, returning to your felt sense of here and now, and start fresh.

ACTIVITY Word Scramble

Randomly think of twelve separate words. Write them down in the columns below.

1.	1.	1.
2.	2.	2.
3.	3.	3.
4.	4.	4.

Now, write four sentences with three of the words in each sentence, one from each column. The words can be in whatever order you choose, and you can add words to complete your sentence. The sentences can be realistic or absurd. There are no "right" answers, so just play. Respond quickly to see what happens.

1.

2.

3.

4.

Your sentences may suggest the start of a short story or poem. Or they may inspire a series of drawings or songs. Let your random choices lead to new creations.

What did you learn about choosing and creating?

ACTIVITY Everyday Object Assemblage

Let's try another activity using disposable everyday items you have around the house. You'll be making choices on how to manipulate and arrange the materials to make a spontaneous temporary assemblage.

Materials needed: One letter-sized sheet of paper and a collection of items (paper clips, rubber bands, cotton balls, foil, tissues, gift wrap, tissue paper, and so on) in multiples of three.

- Lay out all the materials in front of you.

- Notice the inherent qualities of each material.

- Place your attention on the blank paper before you.

- Choose how you want to orient the paper.

- You are going to make a temporary assemblage on the page, using as many of the materials as you choose and nothing more.

- The materials can be manipulated in any manner you choose. Do not throw away any pieces not used.

- Notice your mind as you work.

- Pay particular attention to when you are in the flow and when you are not.

- Stop when you feel the composition is complete.

- Appreciate the finished creation.

- Take a picture of it.

Write down any insights about choice and your creative process using the following questions as prompts.

Did you picture what to do first, dive right into manipulating the materials, or a combination of the two?

How did you decide what to use?

What did you notice about your thinking?

What did you discover about these materials as you worked with them?

What determined when the work was complete, if it was complete?

How satisfied were you with the finished piece?

- Disassemble your creation. Do not throw away any parts, used or not, from the first composition.

- Take a few minutes to just sit with the empty paper.

- Using the already manipulated materials and any unused materials from the first composition, make a new arrangement.

- Orient your page in any direction and further manipulate the materials in any manner you choose.

Note that you are now working with materials that have already been altered. How does this affect your new composition and creative process?

This is a fun exercise to try with a partner. You will each make your own first arrangement and then exchange your set of materials for theirs to create the second arrangement.

How was this time different? Write what you discovered here.

Making Choices

Creating occurs with a series of choices. They can be based on our desires, concepts, or habitual patterns. For example, you might choose tulips for a flower arrangement because they are your favorite, they evoke spring, or you are used to working with them. Choices can also be made by deciding what is needed in the moment, as a natural consequence of here and now. When the conditions of the moment determine the choice, there is a freshness of expression. Natural wisdom arises to guide your actions. All this is the energy of the human principle at work.

When I'm arranging flowers, my perceptions guide my decisions. I choose the plant materials and the container after studying where the arrangement will be placed. I consider ahead of time what plant materials are in season. Yet where to place the materials in the container is determined as the process progresses. I look at each branch carefully to determine how it grew toward the sun, deciding what to cut out to emphasize the beauty of its growth line. Each flower is placed to touch and emphasize the space it occupies so that it harmonizes with the rest of the arrangement, creating a cohesive whole.

At different points in the process, I stop and look at the whole. Is an element competing with or confusing the arrangement? If so, I may cut, move, or add material to bring harmony to the composition. Throughout, it feels like I'm making choiceless choices. The materials tell me how best to arrange them.

CONTEMPLATION No Mistakes

View the TED talk "There are No Mistakes on the Bandstand," given by jazz vibraphonist Stefon Harris (http://www.ted.com/ talks/stefon_harris_there_are_no_mistakes_on_the_bandstand). Playing with his combo, he shows how there are no wrong notes in improvisation, only missed opportunities. Only in ignoring the "off-color" note does it stick out like a sore thumb. When the band accepts it into the flow of the performance, shifting their response with a "yes and," it enriches the composition. Using discernment and accommodation, rather than judgment, the performance holds together. This demonstrates the power of nonaggression, toward oneself and others, in the creative process.

- How do you relate to the unexpected, or perhaps even unwanted, in your creative process?

- Write about an experience of "yes and" from one of your creative projects.

When we are grounded in an appreciation of things as they are, there is a natural fluidity to the process. Choosing in this context is open-ended with a sense of curiosity and daring. You see options and choose one, ready for the surprise that may be behind that curtain. It is playful, recognizing that whatever the outcome, it will be workable. Each action is followed by appreciating the new now and here. When we appreciate what is happening, even the unexpected and unwanted in our creative process are seen as opportunities rather than mistakes.

We'll look more closely at how to work with those opportunities in our process in the next chapter.

Taking Action

Those moments when circumstances are not the way you would like them to be are actually very powerful and pivotal moments in the creative process. —Robert Fritz, creator

Sometimes creating, especially larger visions, involves multiple steps and planning that is not always linear. As mentioned in chapter 6, it took me months and several failed attempts before I created smooth gradations of color in my knitwear. As long as the creation is incomplete, there is a discrepancy between what we envision and current reality. This discrepancy is not a void or a sign of failure. It is filled with energy—the fuel for creating.

To avoid the discomfort of the discrepancy, I could have stopped experimenting with different knit and dye techniques. Certainly, there were moments when I thought creating my expression of a knit sunset was impossible. Working with the energy created by the gap between my vision and reality kept me engaged, open, and inquisitive in the process.

I saw each setback as an opportunity for innovation, a chance to clarify and recommit to my vision, incorporating any new

information into the process. Had I settled for the striped sweaters, I never would have invented a new approach. So, working with the discrepancy between current reality and your vision, without compromising either, is essential for creating.

Robert Fritz, in his book *The Path of Least Resistance,* writes about how important it is to have a clear and specific vision and an undistorted view of current reality to generate the energy that fuels the creative process. When we see it, we are more likely to create it. It's not magical thinking. Seeing clearly, we recognize opportunities and actions that will help us achieve our vision. If you visualize your completed creation beside the relative current reality, as if on a split screen, actions and resources come to mind, sometimes when you least expect them.

Once I chose to machine knit panels for dyeing, other actions became clear. I identified what was needed to make a sweater using this technique. These designs became the core of my fledgling knitwear business, Younger Knits, which was an even larger vision.

Creating alters reality, step by step, to manifest your vision. Throughout the process, now and here shift, requiring you to stay present and up to date in your awareness. You channel the energy through your choices and commitment to bring your creation into reality.

Throughout the creative process, you may experience many different states of mind and emotions. You might be in the flow one minute and in confusion and doubt the next. When you are committed to your vision and awake to reality, everything else is workable. Your emotional state need not disrupt the creative process.

There are four actions you can use to cut self-critical chatter as it arises and return to here and now with fresh insight. In the Buddhist tradition, these skillful actions are called pacifying, enriching, magnetizing, and destroying. To become familiar with them, let's experiment with each in the process of making a single creation.

They are especially useful when working with obstacles in your creative process. I present them in the natural order it is best to use them in. You can apply them to all aspects of your life.

Pacifying—Laying the Foundation

Pacify: To bring order, calm, or settle

Art's purpose is to sober and quiet the mind so that it is in accord with what happens. —John Cage

In the excitement of creating, we can sometimes lose our way, getting ahead of ourselves with a speedy mind. This is when pacifying energy is needed to slow down and experience the world properly, so clarity can arise. By quieting the mind first, you are open to subtler levels of perception. You see what matters and can identify the main elements of your creation. Certain sensations stand out within the infinite array "writhing at your feet." With clarity, your creation takes shape, because you see what to accept and what to reject.

ACTIVITY Pacifying

- Settle your mind by meditating or sitting quietly before you start. Let go of all that has gone before to be in the now and here.

- Connect with the physicality of your body and the world through your senses.

- Let your felt experience determine what to express.

- Wait for clarity to arise. Be patient, the world will let you know. Then begin.

- There might be excitement when your first thought strikes. What happens if you sit a little longer, letting it steep, then slowly move into action? Remember the first genuine thought is not always first.

- Choose what media to use.

- Prepare your materials. Use your preparations as a way to slow down further and pay attention.

- Define the basic structure or outline of the creation. What are the bones? Will it be based on a predetermined form, such as writing haiku or turning a wooden bowl, or grow organically as you work?

- Lay out the broad strokes of the composition with initial sketches, outlines, chord progressions, and so on. This will be the backbone or structure of the expression.

The foundation defines enough of the vision to set a course of action to achieve it. Return to pacifying when you feel lost in the process. It will help clarify what matters most.

Enriching: Exploring the Options

Enrich: To enhance, adorn, increase some desirable quality

Now that you have the basic structure of the creation, it's time to flesh out the details and explore options to shape it into a specific vision. With a settled mind, awareness of your senses connects you to the bounty of the world. That connection refills your creative well. Take time at this stage to play and experiment with new ideas.

Look at your composition. Does it fully express what you want to say? What more is needed to bring the idea to life? Now is the time for enriching action. Not all creations need to be lavish. It's a matter of personal style and taste; you decide. Sometimes a minimal arrangement is enough. With minimalist expressions, the details stand out, so they require more attention.

ACTIVITY Enriching

- Now is the time to play.

- Try out different techniques.

- Visualize different outcomes to see what feels right.

- You are in the midst of adorning space with color, texture, pattern, and so on.

- What can you add to the composition to build relationships between the disparate parts to create a cohesive whole?

- Now is not the time to edit.

- Experiment. An expansive view is needed to go beyond your habitual responses.

- What will help to communicate your expression? Add what is needed, not necessarily what you want.

You are working out the specifics, always returning to the felt sense to see if it feels genuine.

Magnetizing: Focusing the Energy

Magnetize: To draw in or seduce

All art is experience, yet all experience is not art. The artist chooses from experience that which he [she] defines out as art, possibly because it has not yet been experienced enough or because it needs to be experienced more. —James Turrell, installation artist

Now that ideas are flowing, maybe there are too many ideas. How do you find focus and discern what to use? In Tibetan culture, there is a term for places or things of "inherent richness" found in the phenomenal world, *yün*. We recognize yün when shopping for the choicest cut of meat or freshest flowers. They are the ones with the most life in them. That vividness entices and draws us in. This is the quality of magnetizing energy.

Chögyam Trungpa Rinpoche took his students to shop for ties, asking them to choose one based on yün. Yün attracts you based on the inherent sensual qualities of the object, for example, the powerful scent of an exquisite rose or the richness of a fine chocolate.

ACTIVITY Yün Hunt

- Head out on a yün hunt.

- Take a trip to your favorite store or a place in nature.

- Take pictures of any vividness that magnetizes you and place your images on this blank page to remind you of the inherent richness in our world.

Now take a look at your own creation. What do you find compelling about the work?

Looking at your work with discriminating awareness, you see where there is energy, what supports it, and what is superfluous. You are refining your expression to have impact. That power seduces the viewer. Now you are in the heart of the creative process, where the passion/compassion lies. You are offering a gift that goes beyond words (except, of course, if it is words); feelings are evoked through the art.

How much of your subject do you reveal? When you offer only part of the story, the viewer is invited in to complete the rest. The mystery encourages their active engagement with the creation. This is part of the magnetizing energy principle. You don't have to spell everything out.

ACTIVITY What Magnetizes You?

Study other works of art, performances, or writing that attracts you. What qualities make them so appealing? You'll learn more about magnetizing energy by taking time to notice it in other artists' work.

- Visit a gallery, attend a performance, or read a story.

- Notice what feels vivid and alive.

- What draws you in and keeps you enthralled?

 Study the details of your experience.

Write about what you found visually and/or emotionally compelling in your art experience.

How, if at all, are these elements or qualities present in your own work?

What did you learn about magnetizing energy?

What would bring that quality into your current creation?

Destroying: Editing and Letting Go

Destroy: To eliminate, erase, or eradicate

Every act of creation is first of all an act of destruction.
—Pablo Picasso, painter

All creating includes destroying, otherwise nothing would change. At some point in your creative process, you may need to destroy all or part of your creation. It's called editing. Rather than seeing it as an ending, each change is a transition in the flow of life. Both you and the work are being transformed through the process. Indeed, life's energy is in a constant state of flux. In the end, you need to let go of this creation to move on to the next. It may not mean total destruction. What needs to be eradicated or erased from your composition to benefit the whole?

I enjoy making traditional Japanese flower arrangements, known as *ikebana*. The plant material, having been cut from its source of

life, is already dying. The ephemeral nature of the art form makes it so poignant, fading away in a matter of days. When I get too attached to my creations, I remember the Tibetan monks working for days creating intricate sand mandalas, only to destroy them in a matter of minutes, scattering the sand into a waterway to be carried out to sea. This is a lesson in impermanence.

Consider holding your creations with a light touch, otherwise they bind you. Remember they came through you but are not you. Not all art needs to be kept in perpetuity. There is something quite freeing about destroying a work once it is complete. This may seem drastic to you, but I encourage you to try it. It helps with the inventory storage issues too! Cultivating detachment from the creation opens up new avenues of self-discovery as an artist.

What needs destroying in your current creation?

How do you honor letting go of the finished work?

ACTIVITY Impermanent Creating

What if you let go of what you create, not out of judgment, but rather out of appreciation? With this next activity you will create something that is not meant to last. Its impermanence will be part of its expression. Enjoy it from start to finish as you would a fine meal or a story told for the first time.

- Make a temporary creation using natural materials that have a limited lifespan or will be consumed in some way.

- Don't record the creation in any way. Just appreciate it as it changes over time.

- Then discard anything that remains.

Write about the experience here.

ACTIVITY Destruction Construction

With this exercise, you'll deconstruct one of your creations to make something new. Your creative horizons expand when you can detach from outcomes. Any time you feel weighed down by a solidified point of view, consider destroying it to allow something fresh to arise. This is true whether you are working with a physical creation or a mental construct. Your attachment to things and ideas not only binds them to you, but also you to them, limiting your ability to transform as situations change. Letting go is a practice that prepares us for the losses we will inevitably experience in life.

- Take one of your writings, drawings, or compositions and cut it into pieces.

- Then construct a new composition using any of the parts and additional materials you choose.

Write about the experience here.

ACTIVITY Creating With All the Energies

For this activity, explore how each of these energies shifts an expression.

- Use one of your completed works. Either an original or duplicate is fine.

- Extract four separate parts of the composition.

- Use each part as the starting point of a new creation.

- Emphasize one action and its qualities over the others in each composition, with one more pacifying, another more enriching, one magnetizing, and one destroying.

- Notice your state of mind while you work on each and how it feels to view each creation afterward.

What did you notice?

How do the compositions differ?

Was it easier to work with certain energies than others?

Creating a World

Each creative expression alters space by touching it with words, gestures, forms, or sounds, creating an experience. In taking action, you see the outcome of your efforts. You learn more about yourself and the world as a result. You can extend that learning into other parts of your life as you train your mind to be present and aware. The four actions, in particular, are useful for working with obstacles wherever they arise. Working skillfully with our art and life requires practice. We'll explore what an ongoing contemplative art practice could be in the next chapter.

Chapter 8

Practicing a Practice

To practice means to perform, in the face of all obstacles, some act of vision, of faith, of desire…. First comes the study and practice of the craft…. Then comes the cultivation of the being from which whatever you have to say comes…while the individual becomes greater, the personal becomes less personal. —Martha Graham, choreographer

Our current situation in life is shaped by causes and conditions coming together from the past. While it may feel like we are victims of circumstance, now is always a fresh moment. In taking action now, we impact the future. We create with greater skill when we are mindful and aware in the present. Any practice that trains us to create from the fresh moment is, therefore, a powerful tool.

That is why creators throughout time have been instrumental in shaping society. From the many inventions of Leonardo da Vinci to the visionary businesses of Elon Musk, creative minds have altered our world. We see this in the work of R. Buckminster Fuller, the choreography of Martha Graham, the paintings of Georgia O'Keeffe, or the music of Jimi Hendrix. Unconstrained by the past, they acted

in their present with an eye toward the future. Their freedom of expression came from a disciplined and committed approach to their art form. This is why training in a creative discipline is so empowering.

We'll look at the role of discipline and practice in this chapter—how you can create a sustainable practice and fully integrate a contemplative creative outlook into your life.

Practice as Path

Practice is essential to becoming a skillful creator. In a sense, art making is a very blue-collar activity. You roll up your sleeves and get to work, often repetitive work: practicing scales, filling sketchbooks, repeating dance moves over and over until you master them. This requires discipline and dedication.

Eventually, with practice, you no longer struggle with your materials with hit or miss results. You become fluent in your expression. You energize and build momentum in your creative life by committing to a practice. With mastery, the language of the art form becomes your own.

Growth is seldom linear, happening gradually and organically with practice. You can track your practice over time by repeating the same creative activity periodically. Reviewing the results offers insight into your patterns of growth as a creator.

ACTIVITY Daily Practice

- Choose one creative activity from the previous chapters, such as writing a sense poem, object arranging, mindful drawing, twenty-minute dance, or one of your own ideas.

- Practice it daily for a minimum of two weeks, ideally for a month.

- Journal about the experience daily and track it with the chart on the next page.

How did your practice differ from day to day?

What discoveries did you make along the way?

How did the daily practice affect you as a creator?

What impact did it have on other parts of your life?

daily practice

my activity:

	mood	insights	outcome
m			
t			
w			
t			
f			
s			
s			

Setting the Stage

It is not making things that is difficult, but putting ourselves in condition to make them. —Constantin Brancusi, sculptor

Making time and space for creating requires discipline and commitment. With so many distractions in daily life, our minds are often scattered. Studio time is postponed because of other demands: kids, work, friends, and so on. It takes conscious effort to set aside the "to-do" lists and mental chatter. The transition is easier when you schedule creative time into your week. Be sure others know that for this time and place, you are not to be disturbed. Then, use a physical activity and sensory cues to synchronize your mind and body before you begin to create. Creating a work space that inspires you can help.

These next contemplations and activities are offered as aids to establishing a practice. Use them only if they actually support you doing your practice, not as an obstacle or distraction. Ultimately, it's about getting to know and supporting who you are as a creator.

Your Work Space

Think about your ideal work space and evaluate your current situation. Creating can happen anywhere, yet having a dedicated work space is helpful. Be sure to include in your environment items to feed all your senses, making it an inspiring place to create. What sights, sounds, smells, tastes, and textures inspire you to work? Where do you like to create? In a space with bare white walls or a cluttered, colorful environment? In nature or in an urban environment? There are many options to consider. Write down the key ingredients for your work space.

What balance of stimuli and open space works best for you?

Do you work better alone or in the company of others?

How much space do you need?

If the ideal is out of reach for now, how do you create space that is workable?

What supplies do you need to create?

How can you make wherever you work amenable for your creative process?

What inspires a creative and contemplative state of mind in you?

Include objects and images in your space that inspire you to create. Think of it as sacred space and treat it with care. This infuses the environment with supportive energy. You make creating a priority by honoring the materials and the space where you work. Not sure what works for you? Experiment with different places and configurations. You may want a permanent studio or be inspired to create outside, like landscape artist Andy Goldsworthy. Use your physical awareness to guide your decisions about what works best for you.

ACTIVITY Your Ultimate Creative Space Collage

- Make a collage of words and images here to describe your creating space.

- What steps can you take today to make it real?

- Take at least one action today. Your creative space is one more creation.

Creative Warm-Up Rituals

Having chosen where to work, consider what warm-up activities help you to be present for your creative process, such as taking a walk, playing music, or meditating.

- Choose a practice from chapters 1 to 3, such as meditation, twenty-minute dance, or creating from open space, to synchronize your mind and body before your creative session.

- Cleaning the studio also sets the ground for a contemplative creative session.

- Gather your mind as you gather your materials.

- Experiment with a few activities to find what and when works best for you.

Write about your discoveries here.

Include a ritual to mark your work space as sacred at the start of your session. Make it as simple or elaborate as you like. It can even be as mundane as mindfully making a cup of tea. As in meditation practice, you are forming new habits of behavior to be awake and create.

Suggestions:

- Create an art altar in your work space, placing objects on it that represent creating and each of the senses.

- Make an offering to your sources of inspiration or lineage of creators.

- Light incense, burn sage, or light a candle.

- Set an intention for your practice session.

- At the end of your studio time, dedicate the merit of your session to the benefit of others.

What is your ritual?

Once established, these habits can be used whenever you feel scattered or overwhelmed to clear space for your creative practice. As the practice works you, the studio walls fall away. You start to see your life and the whole world as sacred creative space. Your daily routine is your creative warm up ritual. Once you are riding the creative energy, like a bike, you can consider removing the ritual, as you would training wheels. Or continue the practice to honor the sacredness of your creative experience.

ACTIVITY Filling the Well

It is important to refill the well of inspiration in order to sustain a creative practice over time. We need a balance of nurturing, stimulating, and reflective experiences as creators. It is hard to create when you feel depleted or overextended.

There are plenty of ways to nurture the contemplative creator in you. Here are some ideas to spark your imagination.

- Visit museums, galleries, zoos, gardens, comic book shops

- Shop at flea markets, antique shops, art and book stores

- Listen to music, live or recorded

- Take walks in nature

- Dance

- Read

- Play with children or pets

- Garden

- Travel

- Go to movies

How do you nurture your creative self?

What inspires you to create?

What experiences bring you joy?

Make sure to include these experiences in your daily life. When you feel bountiful, that joy extends into your practice and beyond to enrich others. Aim to do one of these events at least weekly.

ACTIVITY Collections as Inspiration

We often collect items we find inspirational. My ex-husband is totally taken with electronic parts. They are like candies to him. He loves making electronic sculptures with them. For your own collections, anything is fair game.

Describe any collections you may have.

Why did you start collecting them?

What do you find compelling about your collection(s)?

Create something inspired by or incorporating some of your collected treasures.

ACTIVITY Relating to Your Muse

Sometimes you are inspired to create but don't have the time to do it. Write down those inspirations to inspire you when you are at a loss for ideas. Gratitude also connects us to the bounty of creativity.

- Create a list of inspirations and appreciations to feed your muse. It's easy to lose track of inspirational ideas and your motivation. This list can help you reconnect.

- Decorate these pages with images, insights, and ideas for future projects. Use them as a repository of inspiration when your creative well has run dry.

You can expand this into a muse journal, a place to collect experiences to spark future creations.

Finding Your Rhythm

Each person has their own rhythm for creating that may vary over time. Are you a night person or are your thoughts clearest in the morning? Do you fill sketchbooks with drawings or create one work over months or even years? There is no right way to create. Just notice what works for you. It takes mindfulness and awareness to know your rhythms. Rather than comparing your practices to others, let your innate wisdom be your guide. Then you'll create a practice that sustains you over time.

ACTIVITY Tracking Your Rhythms

Track your patterns of creating with copies of the following chart for at least a month.

my creative rhythms

activity	where	start	finish	mood

CONTEMPLATION Your Creative Patterns

You may or may not find a pattern to your creative activity. Yet with more information about how you work, you can develop a sustainable practice.

Contemplate the following questions:

When are you most productive creatively?

Where do you work best?

Do you work better with or without deadlines?

Do you prefer scheduled sessions or spontaneous ones?

How long, typically, is your most productive session?

Do you work best in short sessions, marathons, or something in between?

Is your practice rhythm different depending on the medium?

What else have you observed about your creative rhythms?

If you're not satisfied with your current creative output, rather than judging your behavior, experiment with new rhythms. It may feel awkward at first, so give it time to see if there is benefit with a new approach. As creators, we need challenge as well as nurture. If we stay only in our comfort zone, growth doesn't happen. Part of finding your creative rhythm is learning when to challenge yourself and when to integrate what you've learned into your practice.

Embracing Limitations

The absence of limitations is the enemy of art. —Orson Welles, filmmaker/actor

We might equate art and creativity with freedom of expression, yet there is no such thing as complete freedom. Just being in the physical world means there are limitations. Any art form has its limits based on the medium. Often it is the challenge of limitation that sparks creativity. We set limits with each choice we make in the creative process.

The painter Chuck Close uses voluntary limitations in his process. He is known for his large-scale photorealistic portraits painted from Polaroid head shots. His creative process involves dividing the source image into a grid pattern so that each square of the grid can be enlarged very precisely through a variety of techniques. In some paintings, he limited himself to a single color, using as little paint as possible. In others, he realistically rendered each square with thumbprints or as mini abstract expressionist paintings. In each finished work, the pixelated effect when viewed up close reads as a realistic portrait from a distance.

His experimentation with various limitations using this technique has produced a large body of paintings which continues to grow in new directions. We can use artificial limitations to spark creativity too.

ACTIVITY Working with Limitations

- Create a list of parameters for your practice. You might choose to limit yourself to a single subject, technique, material, or form of expression—or a combination of these.

- Create a new work every day or two using these limitations over the course of a month.

What did you learn about your creativity with this exercise?

You may also have physical limitations that change how you create over time, yet you can always be a creator. Many artists, after becoming disabled, developed new techniques to create some of their strongest work. Think of Matisse's cutouts created while bedridden or Chuck Close's large portraits after his paralyzing stroke. When I was too weak to machine knit after my heart surgery, I turned to contemplative photography. Now with a tremor developing in my left hand due to Parkinson's Disease, holding a camera steady is more difficult. Still, I used many of my earlier photographs, new sketches, and Photoshop to produce fresh illustrations for this book.

Limitations as Opportunities

Contemplate your limitations and how they impact your creative process.

What are your limits?

How have they affected the way you work?

What are the limits of your media?

How do you use limitations to spark creativity in your work?

Creating as Path

Awareness practice is not just formal sitting meditation or meditation-in-action alone. It is a unique training practice in how to behave as an inspired human being.... That is what is meant by being an artist. —Chögyam Trungpa Rinpoche, *True Perception: The Path of Dharma Art*

Identifying your inspiration for creating makes it easier to sustain a practice. Your motivation may change over time and depend on the activity, so taking time for periodic self-reflection is helpful.

CONTEMPLATION Motivation

Contemplate what is motivating you to create at this time.

What thoughts, sensations, and emotions are present as you contemplate this?

What inspires you as a creative person?

How does your creative practice affect other parts of your life?

I am motivated to create so I can shape my life with my actions. Life is not simply happening to me; I play an active role. I feel empowered when I create. My contemplative creative practice has led to greater awareness, resilience, and equanimity. I've experienced its life-changing power time and again. This is what motivates me, not only to create, but to encourage others to create too.

For years I've taught seniors and college students the technical aspects of digital photography, including how to use it as a contemplative practice. Most students wanted to learn how to use their camera to take better pictures of their pets, grandchildren, or vacations. Yet they quickly learned that how they saw had a greater impact on their photos than any technical knowledge of the camera. They learned to see light, color, and texture—not just cats, flowers, or children. Life was more engaging because they started seeing everything as if for the first time. They began to find photographic inspiration everywhere, so they started carrying their cameras with them all the time. Each day was a new adventure because they were paying attention to the details of life. Photography became their contemplative art practice.

This greater awareness extended beyond the visual world to impact their relationships with friends and family. They were more tolerant of others because they recognized their own reactive filters. The rigors of a creative practice will shape the way we think and act beyond the studio. Ultimately, any art practice that heightens our awareness can impact how we behave as human beings.

Having a teacher or mentor who has integrated the practice into their life is valuable because you don't know what you don't know. Ideally, their mentorship extends beyond the technical aspects of your art or craft to include your development as an inspired human being. This takes letting go of your limited sense of self and learning to work from an egoless perspective. Your creative practice becomes a path of discovery, a way of living, not only a form of self-expression.

We needn't worry about our individuality, as our unique expression will be evident even working with a traditional art discipline, such as calligraphy or haiku. For example, students of Japanese flower arranging, or ikebana, repeat the same basic arrangements to learn how to work with the tools and properties of different plant materials. They are learning the language of line, mass, and color as it pertains to plant life.

Only after mastering these basic forms does the teacher encourage them to make their own freestyle arrangements. In order to create a harmonious arrangement, the student learns first to work with nature on its own terms, not just as a vehicle for their ego's expression.

The basic lessons of the discipline provide the student with a wealth of wisdom to apply to their life. If, however, the student is impatient to skip the lessons and make their own statement, those discoveries are never made. This is the value of studying a traditional form that has centuries of wisdom enshrined in its practices.

There are choices to be made even within the basic arrangements that will make each one unique; there's no need to cook it up. I have seen this so many times in ikebana class. Even when students work with the same materials, containers, and arrangement, each is different, showing not only their level of mastery, but also their distinctive personality. Even the simple act of making a dot on paper will be different for each person. And, as you may have discovered when repeating the same exercise for several days, your own expressions change from day to day.

By embracing limitation, there is the possibility for growth. The practice shapes you as much as any creation you make with it, stretching you beyond your habitual patterns of expression.

Personal Practice Experience

Have you studied a formalized practice? Possibly a martial art, art medium, traditional craft, or sport?

How has the discipline shaped your life?

Consider studying with a master you admire, either in person or online. Regardless of how advanced your own practice may be, approach it with beginner's mind and see how it informs your work. The creative path is a commitment to a practice and discipline, a way of being in the world. When you step onto that path, you are inviting personal transformation and insight into your life. Your creations will be a record of that journey.

Part 4

relate

Chapter 9

Contemplating the Creation

Creating inspired by the present moment may be a new experience for you, especially being open and aware with your sense perceptions as your guide rather than a preconceived concept. When you create using this approach, a genuinely fresh expression naturally arises, one that may surprise you as much as delight others. You can trust that creativity will happen without needing to overthink and struggle in the process.

In the past, perhaps you decided ahead of time to tell a story, express an emotion, or share a specific idea through your work. Or you worked with a particular process that would determine the outcome based on a conceptual framework. In any case, you started with a goal to communicate something to your audience and a finished result you wanted to create. It was successful if it looked and felt as you imagined and got the response you wanted.

With a contemplative art practice, you may not know what you are creating until it is finished. It is taking shape from your felt sense of now, of being on the spot. In this practice, you are the audience and the artist. When the work is complete, you can look at it freshly. You can ask, "What is its message?" Now that it is done, it has a life

of its own. It is a record of your creative process, a postcard from the journey. What can it tell you? Contemplating finished artwork, both your own and others', is a wonderful practice of self-discovery.

Viewing Your Work

Looking contemplatively at your own art reveals information about your state of being when you made the work. This is not about critiques or judgment. It is a chance to discover more about yourself through your creation. In this way, there are no mistakes or failures, only more of your experience to explore. Just like sitting with the flow of emotions and thoughts in meditation, you are getting to know and befriend yourself as you are in this process.

It is a chance to see your mind on a page. Chögyam Trungpa Rinpoche said when speaking of calligraphy, "You could actually sum up the history of your life in one stroke—that's possible." Everything can be distilled into that one action; all the causes and conditions that brought you to this moment in time can be made visible in that one stroke.

Sometimes the message is obvious, and at other times, it only reveals itself after sitting with the work for a while. This is not about inventing stories or overanalyzing what you made. It is simple appreciation, allowing any fresh insights to naturally arise. The making of art puts your thoughts and experiences into physical form to contemplate after the fact. Now that they are outside your head, you may see them with greater clarity.

In the process of looking, you also see any habitual patterns of relating to your mind and world. The inner critic appears to short circuit the discovery process with judgments about what you have done rather than appreciating what has been created as it is. "Oh, I made that hand too big"; "That's not what I meant to say"; "I could

have chosen a better...." You can notice these thoughts and gently return to just looking. Instead ask, "What is that perceived 'flaw' telling me, just as it is?" Can you look beyond your desire to change something? Rather than seeing it as good or bad, what does it say about your experience in that moment?

John Cage created a series of etchings late in life. In them, he placed shapes on an etching plate based on random throws of the I Ching. He was asked if he ever changed the resulting composition based on his own preferences. He responded, "When I find myself at that point, in the position of someone who would change some-thing—at that point I don't change it, I change myself. It's for that reason that I have said that instead of self-expression, I'm involved in self-alteration." Allowing a creation to alter us, without filtering it based on our likes or dislikes, can be very freeing and informative, just as you may have found in appreciating other things as they are. We can then receive messages beyond our habitual ways of seeing and thinking.

PRACTICE Viewing Your Work

- Select one of your creations as your object of meditation. Choose a creation from one of the activities or one done for its own sake.

- Set a timer for fifteen minutes so you won't be looking at the clock.

- Sit comfortably with the work in front of you at an easy viewing or listening distance.

- Place your attention on the work, as if perceiving it for the first time.

- Notice your thoughts, but don't let them take you too far away from the physical act of looking.

- Repeatedly return with a light touch to being inquisitive about your experience.

- Feel the weight and presence of the art in relationship to you and the space around it.

- Notice the physical qualities of the art.

- The creation is not you, though it is a representation of your experience.

- Now that the work is complete, be open to any messages it may have for you.

- Notice if you start to get bored, critical, or stray from your direct experience of the work. If you do, close your eyes or shift focus briefly, then return again fresh to the creation.

- At the end of fifteen minutes, write down any insights that arose in your contemplation. Pay particular attention to any thoughts that have some energy behind them.

Art is communication. You may have created the work expecting something specific to be communicated; still, with contemplation, something different may reveal itself. I've learned that months or years can pass before I discover why I chose what I chose to create. This is an example of one creation that continues to enlighten me.

My Story of Creating and Viewing

Sometimes, a creation comes through us from a place beyond our conscious mind, offering deeper truths yet to be discovered. I learned the real magic of art making, almost thirty years ago, when I took part in a year-long process called "The Way of the Doll," guided by ceramic sculptor Cassandra Light. Each participant created a figure made of porcelain and mixed media. The "doll" slowly evolved over the course of the year as part of a guided shamanic journey into our deepest wounds to find the healing power of self-love. Along the way, we created specific parts of the doll's body as we shared our personal archetypal journey with the group.

At one point, Cassandra asked us to strike the pose of the figure, to help us create our doll's hand gestures. I immediately cupped my left hand close to the body at waist height, while extending my right hand forward, palm up, with three fingers curled back and the index finger pointing gently outward.

I didn't know why I took this stance. Yet when I started shopping for accessories to clothe my figure, I was drawn to two *malas,* or Buddhist prayer beads, to be held in my figure's cupped left hand. I

later learned that you typically hold malas in your left hand during practice. Later at a flea market, I discovered a humble thatched birdcage. Suddenly I knew the right index finger was extended to hold the birdcage.

More than three quarters of the way through the year, we finally put the body parts together to make a whole being. My doll, as well as many others, was a life-sized figure with glass doll eyes. Suddenly, he came to life with a presence of his own. It was a major revelation for me to meet him for the first time. He emerged as a golden monk once I connected his head, hands, and feet to an armature.

I'd shown the head to a friend earlier in the process. The expression reminded him of the Dalai Lama. This led me to read about the Dalai Lama and Tibetan Buddhism. I named the sculpture Avalokiteshvara, or "Avie" for short, after the Bodhisattva of Compassion, because I learned the Dalai Lama was considered the current incarnation of this deity. But I knew very little about Tibetan Buddhism, or what this meant, other than acknowledging my sculpture looked like a compassionate being.

Ten years later, I took refuge in the Tibetan Vajrayana Buddhist path and began learning what this creation really meant. As my study of Tibetan Buddhism progressed, more and more of the symbolic imagery I had intuitively chosen for "Avie" revealed itself to me.

The malas, which are now part of my daily practice, are used to count recitations of mantras, for example. One mala was made of bodhi tree seeds, from the tree where the Buddha sat when he attained enlightenment. The second set has bone beads in the shape of skulls that are used to contemplate impermanence and the preciousness of this human birth in the Tibetan tradition.

In the same way, several other aspects of this figure relate to specific teachings in the Vajrayana Buddhist tradition. Thus, this figure, which came through me, continues to be a teacher to me long after its creation.

The figure is also a postcard from my yearlong journey, a compassionate being that expresses the tender attention I gave myself and the work as it unfolded.

Viewing Other Artists' Work

Making meaning of a work of art is a subjective practice, for in truth, you are always filtering the world based on your experience. You can apply the contemplative art-viewing process to the work of others, as well as your own. The practice will give you insights into yourself, as the audience, even as you attempt to understand the work from the artist's viewpoint.

ACTIVITY Viewing Others' Work

- Wander through a museum or gallery until a particular work of art attracts your attention.

- Spend at least five minutes just looking at this work as your object of contemplation.

- Write about the following aspects of the work in this order.

- Describe what you actually perceive, listing aspects in the order you are aware of them. These are qualities or visual elements in the work, such as black lines, a red circle, a man in shadow stooped over a box, and so on.

- Describe the relationships between elements in the work and even between the work and the space around it: for example, *the man is in the lower corner of the canvas dwarfed by a large expanse of open space, and the painting sits alone at the end of a long corridor with light streaming in from one side.* Write down these observations.

- Sit for at least another ten minutes after writing your description and feel your body in relationship to the work.

- What sensations and emotions do you feel as you look at the work, if any? Write these down, as well.

- What insight or meaning appears based on your observation? Free associate thoughts that come from your experience and your physical reaction to the work. Write these down.

All these reflections represent your personal experience of the artist's work. Art is what happens in the gap between you, the art, and the artist. An artist creates an expression of an experience from their point of view. The work then has its own presence independent of the artist's mind and intention. What we experience in viewing the work is triggered by our own associations, projections, and past experiences. So, the "meaning" of the work is fluid and lies somewhere in that gap.

I experienced this truth with my painting that depicts a Black male dancer leaping into the sky, reaching for a fragment of rainbow. For me, it was an expression of the groundlessness I felt at the end of my marriage—the freedom and fear of that experience. Because of the recent Supreme Court decision on gay marriage, when I displayed the painting in an exhibit, several viewers saw it as an expression of gay liberation, because of the rainbow. Freedom and risk-taking was communicated. Still, it had a different meaning for the audience, based on their own assumptions. The work itself is independent of either meaning. Being open to others' interpretations of our work can be quite enlightening, too.

Others Viewing Your Work

We provide an experience to others when we present our art for viewing. While you may have a specific idea you want to communicate, ultimately, what others perceive is filtered through their own experience. You may choose to create work only for yourself, for self-expression and reflection. Still, by showing your work to others, you give them an opportunity to be influenced by the work. This can be an act of generosity. You are sharing a moment of awareness with them.

Invite a friend to view one of your works. Let them know beforehand that you are curious about their experience as a fresh perspective on your work. This is not a critique. You are not asking for suggestions on what they would do differently, if they like or dislike it, whose work it reminds them of, or any criticism. You simply want to know what they perceive and experience through the work.

Try not to justify, explain, or defend the work in any way. Just listen. Remember that the work is not you, and any expression they offer is about their experience. This allows you to learn more about

them, as well as the work. This exercise helps to see how others' perceptions differ from your own. Contemplative viewing can take many forms. Approach this exercise with open curiosity and appreciation of your audience, their experience, and the creation.

ACTIVITY Others Viewing Your Work

Materials needed: Notepad and pen

- Ask the other person to first describe what they actually see or hear in objective terms. Remember this is not a critique, just a description of what is actually there. It may be difficult for someone who is unaccustomed to just looking to do so, at first. Be patient and offer an example by describing something else in your space. For example, describe a chair in the room based on its attributes. It is wooden, straight backed, with a reed seat, with curved legs that have four grooves. This may seem like basic information, but you might be surprised what others see that you may not.

- Let them know you will be taking notes as they speak or ask if you can record them.

- Next, ask them to express any feelings they experience as a result of the work. Once again, like and dislike are not helpful. "I feel _____" (sad, joyful, hopeful, depressed, or indifferent, for instance) is a more useful descriptor to express the emotion. Listen without judgment. What is most important for your exchange is that their response is genuine.

- Finally, ask them to sit with the work for a few moments with you. Then, ask what meaning the work has for them. It is fine if nothing arises. This does not reflect good or ill on your creation.

- After you have heard their response, consider opening a dialogue with them by asking if they want to know what your experience or intention was for the work, without being defensive. Perhaps you have new insights based on their experience. Or you can just thank them for their feedback and let it be.

It can be even more enlightening to share the same piece with multiple people to hear a variety of responses and see if there are any common themes. Remember that the "art" happens in that gap between the work, the maker, and the viewer. You created something to be experienced through your art. The rest is beyond your control and not about you.

Once a thought is brought into form, it has a life of its own, just like when a child is born. The process doesn't stop there. It continues to grow as we relate to it as the audience. We imbue it with meaning based on who we are, both as artist and audience. What appears in the gap can be rich with revelation and is ultimately where art happens. What is communicated can be life altering, changing the way we perceive ourselves, others, and the phenomenal world. This is the power of art.

Chapter 10
Creating with Others

I like the idea of collaboration—it pushes you.... It's a richer experience.... It's like jazz, you improvise, you work together, you play off each other, you make something, they make something. —Frank Gehry, architect

So far, this book has been primarily geared toward the solo contemplative creative process. Yet these practices can also be done with others. Creating collaboratively has a richness that is missed when we only work alone. The whole is greater than the sum of its parts. We are, after all, interconnected.

Since art is communication, it implies relationships. When we create, we are developing relationships within a larger web of interconnection. It is impossible to separate out our personal expression from the web of influences that brought us to this moment in time. Even more so, in contemplative practice, something is being communicated through us beyond our ego projections. So, the relationship with ourselves, with others, and with the world we live in is expressed in what we create.

Some art forms can only be manifested by working with others. Each person's contribution adds value to the whole. Working together toward a common goal, in collaboration, can be quite potent, especially when the process is open, respectful, and appreciative of differing perspectives.

The larger the vision, the more you will need others to create it. Can you imagine making a movie, building a building, or producing a clothing line without collaborating with others? Even writing this book, which included many hours of working alone, would not have happened without other people. We'll explore in this chapter how to create contemplatively with others and how collective action can enrich even the work of solo creators.

Expanding Your View

Artists are typically portrayed as loners, divas, or narcissists. Talent is used as an excuse to justify neurotic behaviors and difficult personalities. But to create, there is no requirement to be neurotic, self-centered, or a hermit. There are times when solitude is essential for the creative process, and other times when the creative work needs the skills and insights of others. Regardless, it is possible to create from a state of nonaggression when working with others. Being present with others, as well as ourselves, requires patience, kindness, and respect that we can cultivate with practice.

We all filter the world through the lens of our experience, so when we open to another's point of view, their experiences can enlarge our perspective. We can be inquisitive about a different viewpoint, rather than seeing it as a threat. You can open your mind to another person as you did your senses to the phenomenal world. When collaborating with others, your filters and assumptions are revealed. They act as your mirror. This is one of the benefits of creating with other people.

This is apparent in jazz or theatre improvisation. As Stefon Harris says in his TED talk, a micromanaging band leader "actually limits the artistic possibilities. If I come up and I dictate to the band that I want to play like *this* and I want the music to go *this* way, and I just jump right in…it's kind of chaotic because I'm bullying my ideas.…If I really want the music to go there, the best way for me to do it is to listen.….It has far more to do with what I can perceive than what it is that I can do.….It's about being here in the moment, accepting one another, and allowing creativity to flow." (Emphasis added.)

CONTEMPLATION Mindful Collaboration

Mindfulness, awareness, and appreciation show up in relationships as attention, empathy, kindness, and gratitude.

What would working with others look like if these qualities were present?

What was a time when someone showed you kindness? Empathy? Attention? Gratitude? How did it affect the way you related to them?

In turn, what happened when you extended those qualities to others in a creative process?

ACTIVITY Collaborative Creating

In this activity, you will collaboratively create an art adventure with a friend.

- Meet a friend and plan together a day of shared creative activities.

- Ask your friend what they would like to do with you. It might be something they enjoy that you have never tried before.

- Give them your full attention as they talk about it.

- Notice if your thoughts wander into judgment or drift into your own plans. Drop them and come back to listening.

- Be curious and open to a new experience.

- Notice how you feel.

- Ask for clarification as needed and confirm that you are willing to participate.

- Then make your suggestion.

- Ask that they listen as you have without judging or shifting back to their own plans.

- After answering their questions, decide together how you will combine the activities, whether on the same day or at different times.

- Do them together. At the end, debrief about your shared experience and give thanks.

Reflect on how the experience expanded your view of your friend and the world.

ACTIVITY Creating from a Different Perspective

What would happen if you gave this level of attention and acceptance to a stranger?

- Have a conversation with someone who is not family or a close friend.

- Give them the same level of attention as you gave your friend.

- Based on the conversation, imagine what it would be like to live their life, in as much detail as possible. Obviously, this is a fantasy, as you are not them and cannot divine what their life is like from one conversation. Still, taking time to consider the question is worthwhile. Contemplating another's life can keep us from solidifying our personal view of the world.

- Create an expression of your imagined life. You might choose to write a story from that perspective, draw a picture of the other person as a child, or write a song that expresses what you imagine is their emotional state of being, for example.

Write any insights from this exercise here.

Collaborating with Another

The creative process is a conversation between the artist, their materials, and the audience. In a solo contemplative practice, you work sometimes at a nonverbal level with a felt sense of things. What happens when there are multiple creators? Group creating can be as contemplative and quiet as a solo practice.

As mentioned earlier, this is how my former husband and I played "art chess," a form of object arranging, on the rocks of Maine. As we walked along the rocky shore, one of us would choose a boulder as a space for an arrangement. As we worked together, it felt like

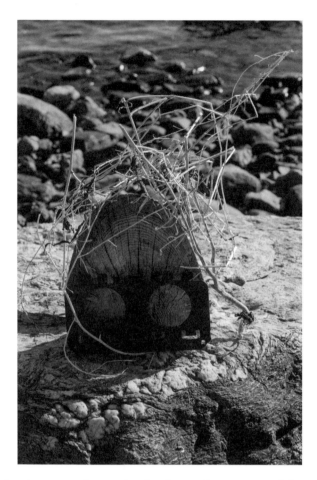

dancing in space, alternating leads, in silence most of the time. We let go of any ego attachment to the result, as we were the only audience for these temporary creations. We could be playful and curious.

It was exciting to see his choice and the new design challenge it created for me, like pulling a wild card. It was impossible to plan my next move or get caught in critical thinking, as the direction of the creation shifted completely with his decision. While some arrangements were more successful than others, rarely did we disagree on which they were. The closer we were to responding from our genuine experience, the fresher and more potent the finished product.

Your Collaborative Experience

Do you work collaboratively with others in your creative process?

What has been your experience with it?

Reflect on a time when it flowed and another time when it was a struggle.

Write about those experiences.

ACTIVITY Taking Turns in Creating

- Invite someone to collaborate with you on a creative project in any art medium.

- Briefly agree to a minimal set of parameters for the creation, the space where you will work, and who will begin.

- Here are a few additional suggested guidelines:

 - Alternate actions between partners. You can pass if you feel there is nothing more you want to add at the time.

 - Work in silence.

 - Stay with the felt sense of it, rather than analyzing or evaluating what was done.

 - Do not adjust the other person's contribution. This is the new here and now.

 - Always stop to appreciate the previous person's contribution and integrate it into your response, before adding your contribution.

 - Feel what is needed in the present, rather than planning ahead.

 - When your partner is working, give them your silent supportive attention. Be curious about not only their final decision, but also their way of working.

 - Notice your reaction to their contribution, then let it go to return to now.

- The work is complete when neither of you has anything more to add.

- Do more than one creation with your collaborator, if time permits.

- Take time to discuss your shared experience of the process afterward.

What did you notice?

How did the relationship with your partner and the work evolve with each creation?

What did you learn as a result?

Solo and Collaborative Communication

Communication in the creative process can be a conversation with just your materials, a collaborative dialogue with another creator, or an open inquiry with a group. Let's look at how these processes differ.

ACTIVITY Solo, Joint, and Group Collaboration

With this activity, you will explore how these various communication forms can alter a creation. Work in the same medium for all three creations and use one similar experience as inspiration. For example, each expression could be a dance inspired by a common childhood experience.

- Choose one creative expression, such as drawing, making a collage, or writing a story or song.

- Do this activity alone.

- Do the same creative activity in collaboration with another person.

- Finally, do the activity with a group of people.

Reflect on your experiences and record your insights here.

Being Part of a Whole

When you sing with a group of people, you learn how to subsume yourself into a group consciousness....That's one of the great feelings—to stop being me for a little while and to become us. That way lies empathy, the great social virtue.
—Brian Eno, composer/artist

I recall the joyful experience I had singing in Grace Cathedral, a gothic cathedral in downtown San Francisco, with the jazz vocalist Bobby McFerrin, who is known for his amazing range of a cappella vocalizations. I was just one of a group of total strangers he was leading in choral improvisations. Under his direction, we became a single unit of great complexity and richness. We filled the sanctuary with otherworldly sounds, something none of us could have achieved alone. With his gentle guidance, each of us tuned ourselves to the whole, changing tones and rhythms at whim, building harmonies with our blended voices. For those moments, we were one.

Some creative projects need teams of people to be realized. These creations can be quite complex and may involve a variety of team approaches. There may be a strong visionary at the helm directing every detail or someone more comfortable with delegating, leaving others with free reign to contribute from their unique perspective. The experience can be frustrating and toxic if egos clash in a fight for control.

The collaborative process can happen through a leaderless collective, listening to each other and building on consensus, leaving the ego out of the equation. When the group is committed to a joint vision, then all contribute and support the form that realizes it best, whether it was their first choice or not. Together, the group determines when the creation feels successful and complete.

Past Group Collaborative Experience

Think about a project you worked on with others.

Describe the project.

What was your role?

What were the dynamics of the relationships?

How did empathy and respect, or lack thereof, impact the results?

How did this project broaden your understanding of yourself and others?

How did it broaden your understanding of the creative process?

Working with others acts as a mirror to show you the places where you get stuck. It challenges you to go beyond your comfort zone and relinquish control. A sense of humor and humility can soften the harsher moments.

Group calligraphy created by Marisela Gould (upper right), Lisa Stanley (bottom) and the author, with Patrick Civiello looking on as part of a Shambhala Art workshop.

ACTIVITY Creating as a Group

In this activity, you'll explore the group creation process in two formats. Document both processes on the next page with pictures and written reflections. In the first, each person will contribute sequentially to the final product, allowing the previous contributions to inform their choices. As the initiator of this creation, you may want to offer a prompt, subject, or parameters for the creation. Or you may want to leave that to a group decision process before you start.

- Engage in a collaborative process where each member of a group contributes one offering to create a final composition, such as in the Taking Turns in Creating Activity. For example, this could be a a group painting made with one brushstroke from each person, or a storytelling circle where each member contributes a sentence to complete a story.

- Continue taking turns until the group decides it is complete.

In the second group creative process, each member will contribute at any point and in any way they choose. Here, the contributor needs to not only pay attention to their own actions but the actions of others simultaneously to create a cohesive whole in the final composition. What role they take in the process is their own choice in negotiation with others.

- Engage in another activity where everyone contributes to a group vision simultaneously. For example, this might be music, dance, or theater improvisation, or a group mural.

- You may provide some prompts to begin with or let the creation arise from the group consensus.

- Allow it to unfold organically from there.

- The group decides when it is done.

Building Community Through Creating

As we come to the end of this chapter, take time to celebrate creating in community. Ultimately, art and culture enliven and shape society. Community is built through shared experience of the diverse expressions from many creators. Take time to appreciate that diversity by creating a feast for the senses with others.

ACTIVITY Celebrating Community

- Plan a sensual feast or other communal event. Make it a group creative process to engage all the senses.

- Ask each participant to contribute something to enrich the occasion with art, music, food, poetry, dance, or their own idea.

Community starts with interacting with at least one other person. If you are an introvert and feel awkward entertaining others, think of an activity you enjoy. How would you share it with another through a creative act?

Write out your plans here documenting what you did and what happened. What did you discover?

Creating art in community takes us beyond questions of ownership and ego. We can enjoy the company of others as we build a communal vision. This strengthens our bonds to each other through shared experience, discovering common ground within our diversity. This is how culture and community are born. What would it look like to create a culture consciously and collectively based on being awake and present? Chögyam Trungpa Rinpoche referred to this as "enlightened society."

Conclusion

Practicing in the World

He [Chögyam Trungpa] truly believed that art can change the world. In this belief, he was focused not on the content of art but on how art can alter perception. If you can change the way people see the world, he taught, then they will change the world they live in. —Carolyn Gimian, editor of *The Collected Works of Chögyam Trungpa Rinpoche*

Perhaps this book has altered your perception. How do you express this new vision? Cultivating compassion and mercy toward ourselves and others is essential for us to remain open and awake to the world. There may be a desire to retreat into our studio to escape the harsh realities of pain and suffering around us. Gentleness is essential in our own awakening. Meditation and our contemplative art practice ultimately provide insight into what to do to be of benefit to others. This is why Chögyam Trungpa Rinpoche placed such emphasis on teaching people how to see things as they are. We need to first wake up to see the world on its own terms, its ugliness and its beauty, to truly be of service to others. Our art practice can be an expression of our compassion for others, a gift of light in times of darkness.

Meditation teaches us how to be present and aware of our experience without manipulation or rejection. Taking time to be with the totality of our experience increases our equanimity and acceptance of differences and discomfort. We begin to see that there's a world beyond our personal reference point, one we can be curious about and relate to creatively. When we do, how we relate to others changes. We can be open to their wisdom, as well as our own.

Giving and Receiving

Many artists struggle with making a living with their art. As someone who has spent most of my life as an art professional marketing my work, I am very sensitive to this issue. I know it is not an easy path. Creators and their work are frequently undervalued in our culture, often with the expectation that their work should be given away for free. There can be hardship and frustration when the market does not support the work we wish to do.

For this reason, I hesitated to share this next exercise, but as a limited experiment, I feel it is worthwhile, to see the power of our work independent of the money. See this not as a validation of your work but rather as a gift of your awakening. What do you wish to offer others through your art? Choose one of your existing works or create something specifically for another. In this, consider what would benefit them and translate your awakened heartfelt expression into your gift for them. Recognize that you cannot know ahead of time how it will be received. Whatever the response, let it be as it is. It does not say anything about you, for the artwork is not you, though it came through you. This is an exercise in letting go and opening your heart to others.

Give something you've made to each of these people: a friend, a loved one, an acquaintance, a stranger, and an adversary or someone you have had a conflict with.

What did you choose for each person?

Were some easier to give than others?

How did you feel with each exchange? (Hint: there are no correct answers.)

How was it received and what, if anything, did you receive in return?

Creating as Your Path

By now, you may have noticed a shift in perspective not only when you create, but also in other parts of your life. Perhaps sensory experiences are more vivid, or you relate to other people differently. The world is becoming your studio. With each choice you make and each action you take, you are creating and experiencing a new reality.

CONTEMPLATION Integrating Contemplative Art into Your Life

You may already have integrated the practices from this book into your daily life. If not, here are some suggestions for you to consider.

Choose one of the following questions to contemplate weekly for at least ten minutes, considering one aspect or relationship in your life at a time. Write down any insights.

- How are your relationships with family, friends, and coworkers altered by relating to them on their own terms?

- What are you creating today with your choice of clothing, friends, work, and other things?

- What if you approached all aspects of your life as a creative process with playfulness and humor?

- How would greater appreciation, awareness, and precision alter the more mundane aspects of your life, such as your home and your daily routines?

If this inspires a creative expression or other activity, take the time to do it.

See what happens and write down the result.

In addition, continue meditating on a daily basis.

Finally, schedule time for one contemplative art activity, separate from any creative projects you are already engaged in, on a regular basis.

CONTEMPLATION Reflecting on the Journey

As we come to the conclusion of this book, reflect back on your journey. Take time to reread your journal notes and review what you have created through the activities in this book.

How did these activities impact your creative process?

How has meditation affected your creative process?

What new insights have you gained about yourself?

About others?

About the world we live in?

How do you see your art altering the perceptions of others?

What matters to you now in your work?

What other discoveries did you make on this journey?

Creating this book has been an amazing journey for me, one that I hope has been of benefit to you. We are actually creating our world together, so creating skillfully with mindfulness and awareness with others contributes to a kinder and more compassionate society. Your creative practice can be your contribution to a saner world, whether you create with others or alone.

Acknowledgments

This book would not exist without the support of my editor, Ryan Buresh. He took a chance on me, as a first-time author/illustrator, to produce my vision of a contemplative, guided art journal instead of the coloring book he first requested. His gentle guidance and advocacy gave me the confidence to create it. Thank you, Ryan, for trusting me.

Thank you to the lineage of creators who were instrumental in shaping me as an artist. Their life-changing teachings inspired me to write this book. Thank you to Robert Fritz, for his extensive writings on creating and the Technologies for Creating training. His techniques have assisted me in creating in all areas of my life, including writing this book.

I pay special homage to my spiritual teacher, Chögyam Trungpa Rinpoche, founder of Shambhala Buddhism, for the dharma art teachings, which are the foundation of this book. His ability to translate Tibetan Buddhist concepts for Western minds, especially artists, continues to impact our culture in so many ways.

And to Steven Saitzyk for developing a curriculum to transmit the dharma art teachings to future generations through his five-part Shambhala Art program and teacher trainings. Deep gratitude to my dear friend and teacher, Marcia Shibata, for introducing me to Shambhala Art and ikebana practice and to Acharya Arawana Hayashi, for her embodied teaching of the dharma art material and its connection to Japanese art concepts. In addition, I want to thank all my fellow Shambhala Art teachers and students who have brought

these teachings to life for me. May this book reflect the wisdom that each of you have so generously shared with me over the years.

On a more personal level, I want to acknowledge the support of my mother, Betty Younger, who was my number one fan when she was alive, a model of the creating paradigm, who introduced me to Robert Fritz's work. To my ex-husband, Guy Marsden, who has been a co-creator on so many creative endeavors, for patiently listening to the entire book as it was being written and offering valuable feedback and support. To the most profound creative relationship I've had in my life with Professor Turtel Onli, MAAT for his mentorship and dedication to life as a consummate professional artist/educator. His under-acknowledged visionary work has been influential for many creators and I am blessed to be one of them. To my sisters, nieces, and nephews, creative souls all, who have supported me on this journey. May each of your lights shine brightly for the benefit of all.

Activity Sources

Calm Abiding Meditation—Adapted from shamatha meditation instruction based on my training as a Shambhala Buddhist meditation instructor.

Twenty-Minute Dance—Based on an exercise of the same title by Shambhala Buddhist teacher, Acharya Arawana Hayashi, a trained Bugaku dancer (a Japanese contemplative dance practice) and founder of Social Presencing Theatre for the Presencing Institute. View her complete exercise here: http://www.presencing.org/files/ tools/PI_Tool_SPT_20MinDance.pdf. This work is licensed by the Presencing Institute—Otto Scharmer, http://www.presencing.com/, permissions under a Creative Commons license.

Visual Awareness—Adapted from *The Practice of Contemplative Photography: Seeing the World with Fresh Eyes* by Andy Karr and Michael Wood.

What Color Is It Really?—Adapted from *Learning to Paint What You See* and *"Handling Color"* from *How to See Color and Paint It* by Arthur Stern.

The following exercises are variations on exercises in the Shambhala Art Program by Steve Saitzyk, which is an experiential five-part curriculum based on the visual dharma art teachings of Chögyam Trungpa Rinpoche.

Seeing Clearly—Variation of the Personal Object Meditation Exercise in Shambhala Art Part 2 and included in *Place Your Thoughts Here* by Steven Saitzyk.

Is This Me?—Adapted from the Party Game and Post-It Note Exercises from Shambhala Art Part 2.

Touching Space & Making an Arrangement—Adapted from Object Arranging Exercises in Shambhala Art Parts 3–5 and the practice instructions given by Chögyam Trungpa Rinpoche.

Yün Hunt—From Chögyam Trungpa Rinpoche as referred to in *Place Your Thoughts Here* by Steven Saitzyk.

Additional Resources

Rebekah Younger—
http://www.rebekahyounger.com and https://www.youngerknits.com

Rebekah Younger's art, creating, coaching, and teaching schedule.

Shambhala Art International Programs—
http://www.shambhalaart.org

Five-part art program developed by Steve Saitzyk.

Robert Fritz—
http://www.RobertFritz.com

Writer and educator on the creative process as a life practice.

Arawana Hayashi—
http://ArawanaHayashi.com

For more information about Social Presencing Theatre.

Shambhala International—
https://shambhala.org/what-is-meditation

For guided meditation instruction with a list of centers and further trainings in meditation practice.

Mindfulness Meditation—
http://www.mindful.org

Mindful magazine for more tips on meditation practice and integrating practice into your daily life.

Miksang (Contemplative Photography)—
http://www.miksang.com or Nalanda Miksang http://www.miksang.org

For workshops in contemplative photography.

Meditation Cushions—Samadhi Store—
http://www.samadhicushions.com

John Cage Trust—
http://johncage.org

For more information about John Cage's music and writings. Also to download the 4'33" app for the iPhone to record your own performance of ambient sounds.

References

Page 9 *There is no such thing as an empty space or an empty time.* Cage, J., and K. Gann. 2013. *Silence: Lectures and Writings, 50th Anniversary Edition.* Middletown, CT: Wesleyan.

Page 9 *Needless to say, when first performed at the rustic Maverick Concert Hall in rural Woodstock, New York, the audience was in an uproar.* Hermes, W. 2000. "The Story Of '4'33," NPR.Org. May 8, 2000. https://www.npr.org/2000/05/08/1073885/4–33.

Page 10 *No day goes by without my making use of that piece in my life and in my work.* Duckworth, W. 1995. *Talking Music: Conversations with John Cage, Philip Glass, Laurie Anderson, and Five Generations of American Experimental Composers.* New York: Schirmer Books.

Page 13 *It isn't necessary that you leave home.* Kafka, F., and D. Frank. 2015. *Aphorisms.* New York: Schocken.

Page 29 *Being without doubt means that you have connected with yourself, that you have experienced mind and body being synchronized together…* Trungpa, C., and C. Gimian. 2007. *Shambhala: The Sacred Path of the Warrior.* Boston: Shambhala.

Page 32 *Practice: Twenty Minute Dance.* Hayashi, A. and O. Scharmer 2018. Creative Commons License: Presencing Institute. http://www.presencing.org/files/tools/PI_Tool_SPT_20MinDance.pdf.

Page 34 *A line is a dot that went for a walk.* Klee, P., and F. Klee. 1968. *The Diaries of Paul Klee, 1898–1918.* Berkeley: University of California Press.

Page 53 *All our knowledge has its origin in our perceptions.* Da Vinci, L. 1883. *The Notebooks of Leonardo Da Vinci, Volume 2.* Jean Paul Richter (trans). New York: Dover.

Page 55 *As the title of artist Robert Irwin's biography suggests, "Seeing Is Forgetting the Name of the Thing One Sees."* Wechsler, L. 2009. *Seeing Is Forgetting the Name of the Thing One Sees: Expanded Edition.* Berkeley: University of California Press.

Page 57 *Activity: Visual Awareness* Karr, A., and M. Wood. 2011. *The Practice of Contemplative Photography: Seeing the World with Fresh Eyes.* Boston: Shambhala.

Page 59 *The mind stands in the way of the eye.* Stern, A. 2015. *How to See Color and Paint It.* London: Churchill & Dunn, Ltd.

Page 75 *If we open our eyes, … our minds, … our hearts, we will find that this world is a magical place.* Trungpa, C., and C. Gimian. 2007. *Shambhala: The Sacred Path of the Warrior.* Boston: Shambhala.

Page 79 *The moment one gives close attention to anything, even a blade of grass, it becomes a mysterious, awesome, indescribably magnificent world in itself.* Smalley, S. L. and D. Watson. 2010. *Fully Present: The Science, Art, and Practice of Mindfulness.* New York: New Directions.

Page 79 *Since we are here, why not be here?* Trungpa, C and J. Lief. 2008. *True Perception: The Path of Dharma Art.* Boston: Shambhala.

Page 85 *Georgia O'Keeffe, when writing about her flower paintings, noted that "to see takes time, like to have a friend takes time."* Pollitzer, A. 1988. *A Woman on Paper: Georgia O'Keeffe.* New York: Simon & Schuster.

Page 90 *Chögyam Trungpa Rinpoche referred to this place as "cool" boredom.* Trungpa, C. 2002. *The Myth of Freedom and the Way of Meditation.* Boston: Shambhala.

Page 97 *Chögyam Trungpa Rinpoche referred to that genuine response as "first thought, best thought."* Trungpa, C. 2008. *True Perception: The Path of Dharma Art.* Edited by J. Lief. Boston: Shambhala.

Page 98 *…such a thing as unconditional expression that does not come from self or other. It manifests out of nowhere like mushrooms in a meadow, like hailstones, like thundershowers.* Trungpa. 2004. *Collected Works Volume 7.* Boston: Shambhala.

Page 102 *Because it all comes down to how you answer a single question: Is the moment of perception—that first moment, before all the abstracting, conceptualizing processes that follow—is that the moment closest to or furthest from the real?* Weschler, L., and B. Cohen. 2002. *Robert Irwin Getty Garden.* Los Angeles: J. Paul Getty Museum.

Page 110 *Activity: Seeing Clearly* Saitzyk, S. 2013. *Place Your Thoughts Here: Meditation for the Creative Mind.* Los Angeles: First Thought Publications.

Page 123 *Love is what creating is all about....* Fritz, R. 1993. *Creating: A Practical Guide to the Creative Process and How to Use It to Create Anything—a Work of Art, a Relationship, a Career or a Better Life.* New York: Ballantine Books.

Page 123 *As knitting was my primary art form, I wanted to create a knit garment to express the beauty of that sunset.* Younger, R., et al. 1995. *Great Knits: Texture and Color Techniques.* Newtown, CT: Taunton Press.

Page 128 *So the bandstand...is really a sacred space...* Harris, S. 2011. "There Are No Mistakes on the Bandstand." New York, NY. To watch the full talk, visit TED.com.

Page 142 *One of the keys to embracing creativity is recognizing that even though it involves risk, you don't die.* Evans, M. 2012. "David Usher on Why You Need to Be More Creative," November 9, 2012. https://www.theglobeandmail.com/report-on-business/small-business/sb-managing/david-usher-on-why-you-need-to-be-more-creative/article5165129/.

Page 153 *Those moments when circumstances are not the way you would like them to be are actually very powerful and pivotal moments in the creative process.* Fritz, R. 1989. *Path of Least Resistance: Learning to Become the Creative Force in Your Own Life.* New York: Ballantine Books.

Page 156 *Pacify: to bring order, calm, or settle.* Editors of the American Heritage Dictionaries. 2015. *American Heritage Dictionary of the English Language, Fifth Edition.* New York: Houghton Mifflin Harcourt.

Page 156 *Art's purpose is to sober and quiet the mind so that it is in accord with what happens.* Brown, K. 2001. *John Cage Visual Art: To Sober and Quiet the Mind.* San Francisco: Crown Point Press.

Page 158 *Enrich: To enhance, adorn, increase some desirable quality.* Editors, *American Heritage Dictionary.*

Page 160 *Magnetize: To draw in or seduce.* Editors, *American Heritage Dictionary.*

Page 160 *All art is experience, yet all experience is not art.* Tuchman, M. ed. 1971. *A Report on the Art and Technology Program of the Los Angeles County Museum of Art, 1967–1971.* Los Angeles: Los Angeles County Museum of Art.

Page 161 *Activity: Yün Hunt* Saitzyk, S. 2015. *Place Your Thoughts Here.* Los Angeles: First Thought Publications.

Page 164 *Destroy: To eliminate, erase, or eradicate.* Editors, *American Heritage Dictionary.*

Page 164 *Every act of creation is first of all an act of destruction.* May, R. 1994. *The Courage to Create.* New York: W. W. Norton & Company.

Page 171 *To practice means to perform, in the face of all obstacles, some act of vision, of faith, of desire.* Graham, M. 1991. *Blood Memory: An Autobigraphy.* New York: Doubleday.

Page 175 *It is not making things that is difficult, but putting ourselves in condition to make them.* Giedion-Welcker, C. 1959. *Constantin Brancusi 1876–1957.* Paris: Editions du Griffin—Braziller.

Page 192 *The absence of limitations is the enemy of art.* Squire, J., ed. 2004. *The Movie Business Book, Third Edition.* New York: Touchstone.

Page 195 *Awareness practice is not just formal sitting meditation or meditation-in-action alone. It is a unique training practice in how to behave as an inspired human being.... That is what is meant by being an artist.* Trungpa. 2008. *True Perception.* Boston: Shambhala.

Page 202 *You could actually sum up the history of your life in one stroke—that's possible.* Trungpa. 2008. *True Perception.* Boston: Shambhala.

Page 203 *When I find myself at that point, in the position of someone who would change something—at that point I don't change it, I change myself.* Brown, K. 2001. *John Cage Visual Art.* San Francisco: Crown Point Press.

Page 205 *I took part in a year-long process called "The Way of the Doll," guided by ceramic sculptor Cassandra Light.* Light, C. 1996. *Way of the Doll: The Art and Craft of Personal Transformation.* San Francisco: Chronicle Books.

Page 213 *I like the idea of collaboration—it pushes you.... It's a richer experience.... It's like jazz, you improvise, you work together, you play off each other, you make something, they make something.* Gehry, F. 2002. "A Master Architect Asks, Now What?" To watch the full talk, visit TED.com.

Page 215 *As Stefon Harris says in his TED talk.* Harris, "There Are No Mistakes on the Bandstand."

Page 224 *When you sing with a group of people, you learn how to subsume yourself into a group consciousness....* Eno, B. 2008. "Singing: The Key to a Long Life." *NPR.Org.* National Public Radio. https://www.npr.org/templates/story/story.php?storyId=97320958.

Page 230 *"enlightened society."* Trungpa, C. and Gimian, C. *Shambhala: The Sacred Path of the Warrior.*

Page 231 *He [Chögyam Trungpa] truly believed that art can change the world.* Trungpa. 2004. *Collected Works Volume 7.* Boston: Shambhala.

Rebekah Younger, MFA, is a multidisciplinary artist with over thirty years of experience as a creative professional, entrepreneur, designer, and teacher. Her work has been exhibited in galleries and museums around the United States, as well as featured in magazines such as *Ornament, FiberARTS, Threads,* and *The Crafts Report.* Younger is trained as a Shambhala Art instructor, a training in which art is viewed as a practice to cultivate an awakened mind and genuine expression beyond aggression. This program, based on the teachings of Chögyam Trungpa Rinpoche (a Tibetan Buddhist teacher of such creatives as Allen Ginsberg, Alice Walker, and Meredith Monk), explores the creative process as a meditative practice and a means of awakening to things as they are. Younger completed a Master of Fine Arts in interdisciplinary arts at Goddard College, with a focus on contemplative art, Buddhism, and photography/video/installation. She lives in Chicago, IL, where she teaches photography, creating, and meditation.

MORE BOOKS for the SPIRITUAL SEEKER

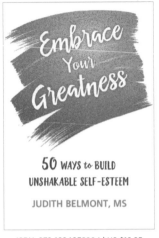

ISBN: 978-1684032204 | US $16.95

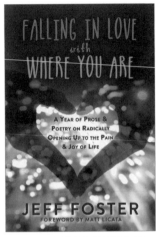

ISBN: 978-1626256415 | US $16.95

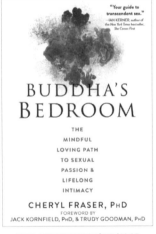

ISBN: 978-1684031184 | US $16.95

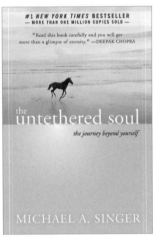

ISBN: 978-1572245372 | US $17.95